CHICHESTER

THROUGH TIME

Philip MacDougall

AMBERLEY PUBLISHING

To Stephanie a true Cicestrian from head to toe

First published 2011

Amberley Publishing
The Hill, Stroud
Gloucestershire GL5 4EP

www.amberley-books.com

Copyright © Philip MacDougall, 2011

The right of Philip MacDougall to be identified
as the Author of this work has been asserted in
accordance with the Copyrights, Designs and
Patents Act 1988.

ISBN 978 1 4456 0463 3

British Library Cataloguing in Publication Data.
A catalogue record for this book is available from
the British Library.

Typeset in 9.5pt on 12pt Celeste.
Typesetting by Amberley Publishing.
Printed in the UK.

Introduction

Time, by its very nature, can be split into three elements: past, present and future. In this respect, *Chichester Through Time* conforms to this format, the photographs reproduced in each of the following sections comparing areas of the city with how it had once looked at some point in the past. As for the future, often ignored by historians as something to be written about in a time not yet reached, this is part of the remit I have given this introduction. Not an attempt to predict how things might change, but a few brief lines on what could usefully be done to ensure that the city has both a sustainable and a worthwhile future.

In terms of its city status, Chichester, replete with its still existing major thoroughfares, was planned and executed by the Romans. It was the Romans who created the vast defensive walls that encircled and marked the outer limits of the city while also establishing the grid pattern of roads that still fundamentally exists within the area of the walls. From the time of the Romans onwards, the city has been allowed to muddle through. Where consistency and planning is discernible it is often a result of being forced to follow that original Roman template, so ensuring that the central area of the city remains spacious, airy and generally uncluttered.

It is, therefore, fortunate that Chichester was a direct product of Roman engineering and the accompanying civic pride that was so much a feature of that particular autocratic period of governance. If it had been otherwise, then any emerging township in this same geographical location would undoubtedly have been a ramshackle overcrowded mess that would have left each subsequent generation demanding the destruction of all that had gone before. Consequently, developers would have been given a green light to crowd into a vastly reduced area of space a number of cheap properties that would have been inappropriate to the real needs of those who inhabited the city. In turn, such buildings would have offered little to any future heritage industry, being nothing less than a ghastly blot on the landscape.

Not to get too hung up on the Romans, there was another important factor that worked to the advantage of the city during its period of early growth. The Romans, through the construction of those defensive walls, had clearly established a city of size and spaciousness that had the opportunity to breathe and expand. Into the north-west quadrant, following close upon the invading Normans, came the established Church in all its glory. Taking virtual full possession of this area of the city, the Church applied similar design standards to those previously laid down by the Romans. With a number of buildings, both aesthetically pleasing and substantial in

nature, they set such high standards that others must have felt the need to strive and reach out for a similar level of absolute perfection. Such buildings that might not have otherwise existed include both Ede's House and Pallant House.

Unfortunately, the light touch approach to the control of developments within the city has become an ideological fact of everyday life within the city. Rather than plan the city for the needs of its citizens, muddling through is still the predominant policy of choice. For far too long, the planners of the city have given in to the wishes of the developers, and more recently, the demands of the motorist. In accepting that people need mobility, it is not necessary to strangle the city and destroy that freedom of movement that a well-planned city should possess. This failure to take a firm hand has, through much of the twentieth century, resulted in the needs of the motor car being the prime factor that underpins most modern developments in the city. Now, with rising oil prices caused by the approach of peak oil supply, there has never been a better time to reverse this trend.

Perhaps the factor that has allowed the dominance of the motor car to continue is that of both district and county-wide administrative bodies having full control over all planning and highway matters that directly affect the city area. With only a small minority of their respective members being city-based, they are themselves dependent upon the car for travelling into the city. As such, they share few of the frustrations of those, in the majority, who access the city through the use of public transport, cycles or walking. Buses, from many areas, are few, infrequent and shortly to be even fewer in number, while walking anywhere beyond the two semi-pedestrianised main streets is much akin to playing Russian roulette. Furthermore, the dangers imposed upon the pedestrian are greatly increased by the encouragement of cars into the city area through the existence of comparatively cheap inner-city car parks and the ease of using nearby roads as an alternative to the outer by-pass.

Those on the District and County Council responsible for planning the future of the city should take a long, hard intake of breath and look at progressive developments taking place in other historical towns of similar size. An increasing number, including Venice, Siena and Dubrovnik, have taken the plunge and banned (or heavily reduced) vehicular access within their historic enclaves. Chichester could do likewise. After all, the process has already begun with two of the streets within the walls having become partially pedestrianised. The Chichester Society supports such an idea, noting that the advantages would include reduced levels of noise, pollution and dust while increasing pedestrian safety and allowing a more relaxed enjoyment of the urban scene.

Unfortunately, and this is always the case when important planning matters are removed from those most affected, there is only compromise and poor judgement. If it was otherwise, Chichester would already have much more extensive centralised car-free areas while the long delayed (will it ever be built?) fully integrated transport interchange would now be complete and in full use.

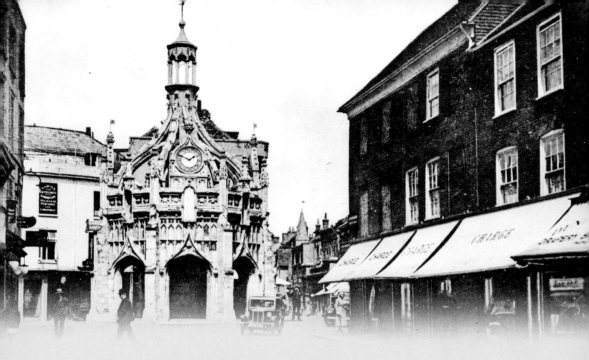

CHAPTER 1

The Shopping Experience

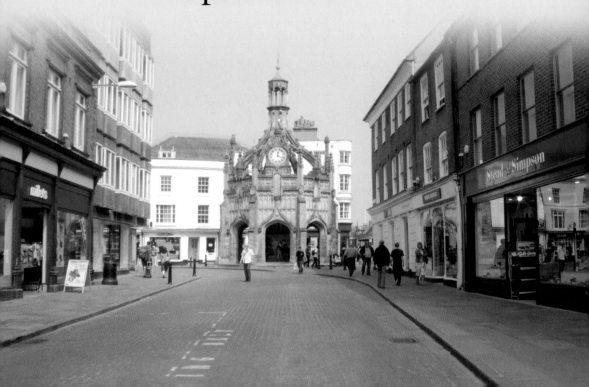

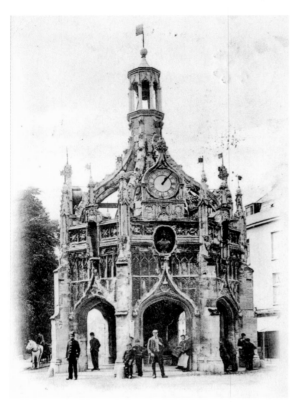

The Market Cross

The Cross, which stands at the very centre of Chichester, was the original shopping experience. Constructed in, or around, 1501, it was given to the city by Bishop Edward Story (1478–1503) as a facility for traders who were too poor to pay the normal market fees. Under the terms of its foundation, traders who were permitted to use it were not only protected from the elements but were not to be subject to any charges whatsoever. On this page the two views of the Cross are separated by almost 110 years, with the earlier view showing the stonework to have been greatly affected by pollution from the city's various coal-fire home hearths. Within the niche a bust of Charles I is visible, this now replaced by a fibreglass replica. On the previous page, where the Cross is viewed from South Street, the earlier view dates to the early 1930s and is dominated on the right by the awnings of Charge & Co, a drapery store and ladies' outfitters that occupied this particular site for much of the twentieth century. Many remember it because it had a reasonably priced restaurant on the upper floor. This was the Regency Grill, which had an entrance round the corner in East Street, next door to the then Midland Bank (now HBSC). A second drapery store, Dunn & Co, stood in South Street and immediately adjacent to Charges, also remaining here until the 1970s.

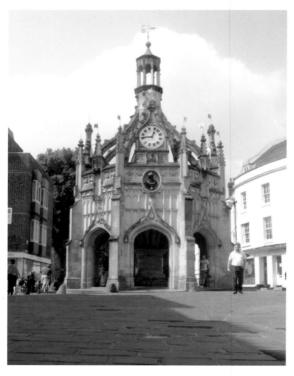

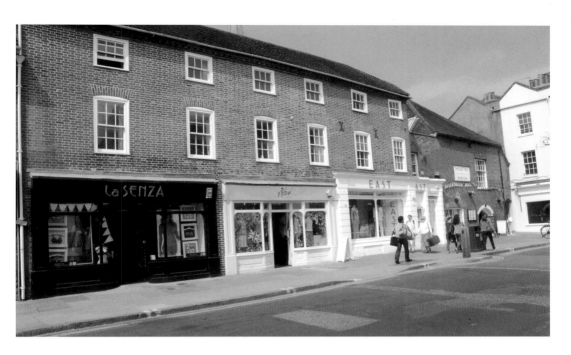

South Street

During the late 1930s, Christmas Hunt was listed as being at No. 15 South Street and selling fancy goods. However, this photograph was taken considerably earlier, possibly the 1920s, with the shop at No. 16, this due to some later re-numbering in this street. By 1950 this same premises had been taken over by Cuddinton Toyland, a children's toy shop. A walk along South Street in 2011 shows that this particular shop is now selling up-market lingerie, being part of the La Senza chain.

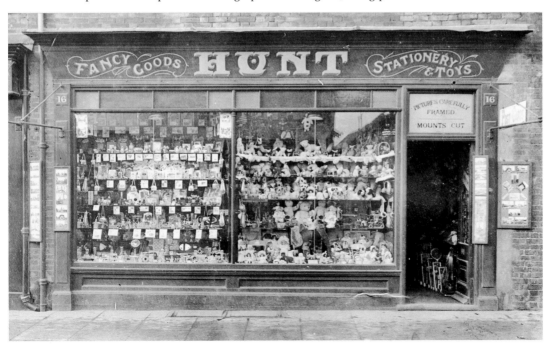

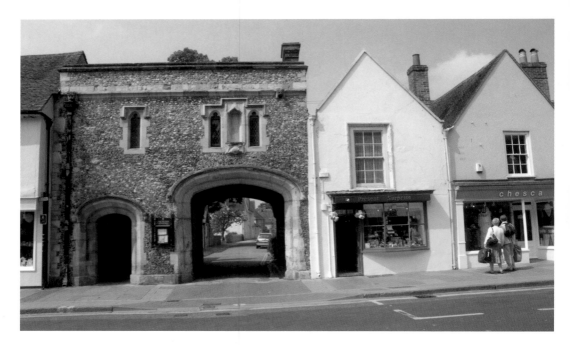

Canon Lane Gate

Further along South Street is Canon Lane Gate with a number of small shops on either side. When the earlier picture was taken, possibly in the 1920s, the shop immediately to the right was Wilfrid W. Bartholomew, a tobacconist who obviously did a good line in Will's Gold Flake. The other two shops in the picture are S. J. Linkins (sports outfitters) and The City Fruit Stores. Currently occupying the site next to Canon Gate is a small gift shop.

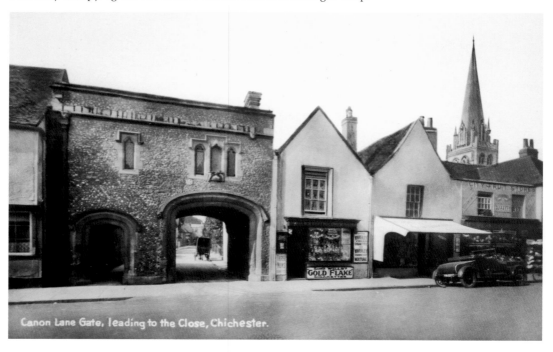

Canon Lane Gate, leading to the Close, Chichester.

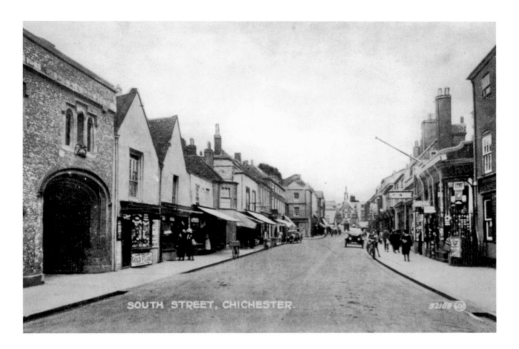

Sussex Daily News

A more general view of South Street looking north towards the Market Cross and seen during the autumn of 1924. Once again, the Canon Gate and its adjoining tobacconist shop are to be seen. On the opposite side of the street are the offices of the *Sussex Daily News* and *Evening Argus* (56 South Street) and C. C. Allen & Sons, a jeweller of 57–59 South Street. The *Sussex Daily News*, once read widely in the city, ceased publishing in 1956. This building became a Pricerite supermarket in the late 1960s, remaining a supermarket, albeit with a different name, until the present day – it is currently part of the Iceland chain of stores.

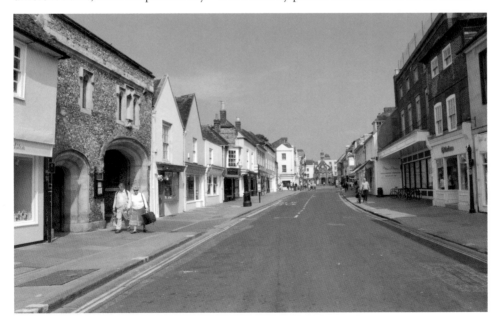

The Department Store

One of the earliest department stores to be found in Chichester was that of the Central Supply Stores owned by Harris and Hall and located at 2 and 3 East Street. Established here sometime before the First World War, the store had a number of specialist departments, including general grocery, colonial produce, wines and spirits, perfumery and medicines. The Central Supply Stores especially prided themselves on their ability to provide any household product and, if not in stock, 'procured promptly'. Perhaps the most obvious successor to Harris and Hall's extensive store was Morants, a department store which at one time occupied an area of West Street that has since been acquired by a further department store, John Lewis (formerly A&N).

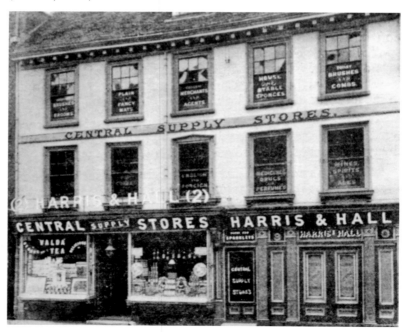

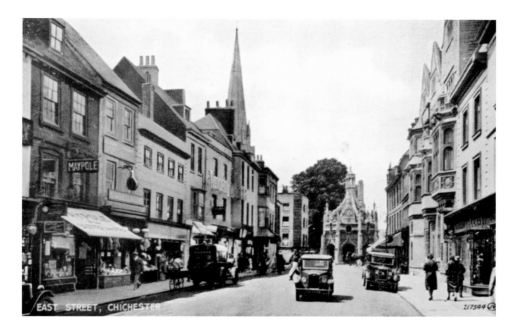

East Street

In the early photograph, East Street is to be seen on a summer's morning in 1932. Among shops on the south side of this street are Maypole Dairy, Kimbell & Son and the chemist's, Timothy White. As regards this last shop, Timothy White, this was later subsumed into Boots with the site now occupied by a Topshop fashion store. On the opposite side of the street are the Westminster Bank (now NatWest) and Jay's, an ironmonger (nearest to camera). In the modern day photograph, the NatWest Bank is clearly visible while the premises of the former ironmonger's have been replaced by a more recent building occupied by HMV.

East Street (looking east)

With the Market Cross behind the camera, the *c.* 1901 photograph shows that the left hand side of the street is home to several financial institutions, with the Westminster Bank occupying the same site (Nos 5 & 6) as its latter day successor, the NatWest. On the right hand side of the street is a wider range of shops, with Highground Davis (No. 91) to be taken over by Timothy Whites later in the century.

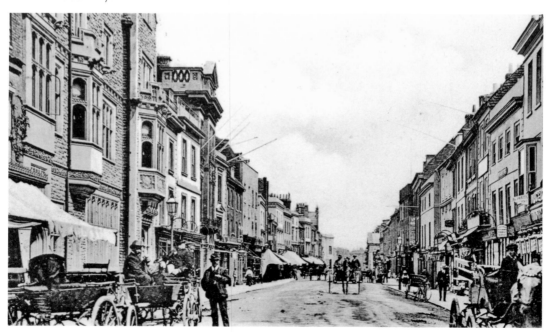

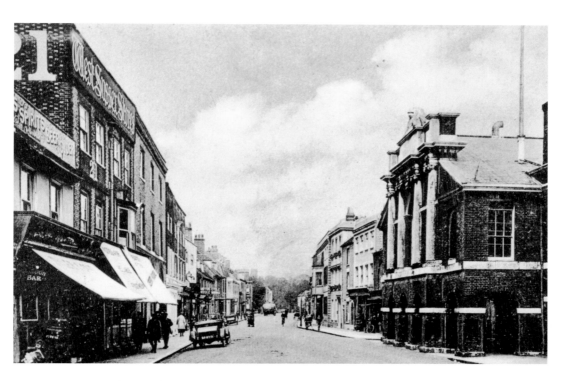

North Street (Council House)

The earlier photograph, *c.* 1929, taken well before pedestrianisation was dreamed of, has several buildings of interest, including the Council House on the right. On the left, and clearly marked as 21 North Street, is the West Sussex Stores (later the site of John Perrings Furnishings) while the adjacent store (moving towards the camera) was a wine and spirit merchant run by Tyler & Co.

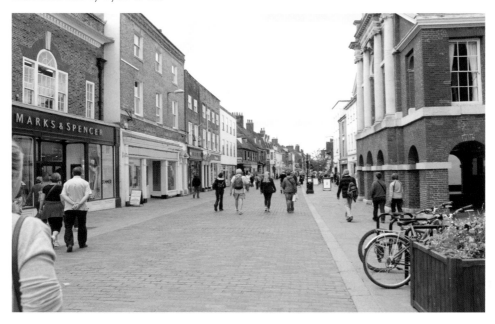

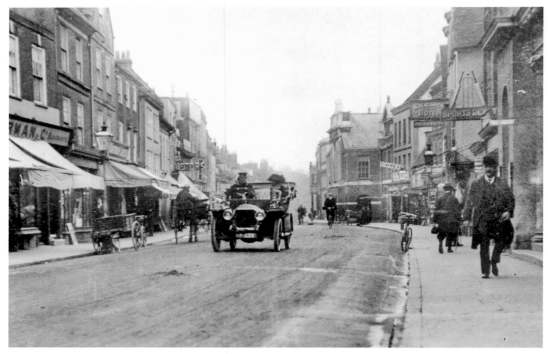

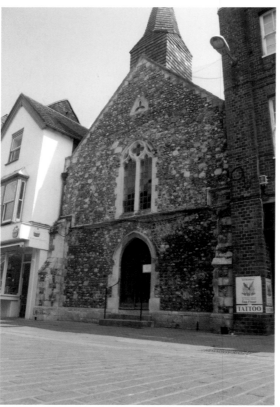

North Street (looking north)

A further view of North Street, this time with a photograph that precedes the outbreak of the First World War. To the right is the Buttermarket together with several pubs and restaurants. The inclusion on this page of the former church of St Olave, now a bookshop, is a reminder of the age of this particular street, St Olave's possibly having its origins in the eleventh century.

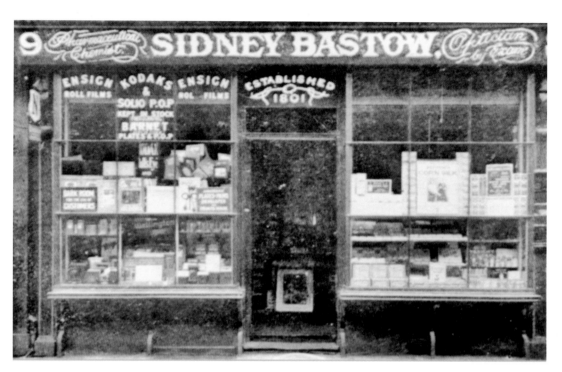

Sidney Bastow

Two further shops in North Street, but separated by almost one hundred years. Sidney Bastow was once located at 9 North Street, with this picture dating back to the 1920s and a time when photographic supplies were usually obtained from a chemist rather than a specialised photographic dealer. Bastow's continued to trade from this site into the 1970s, before making a move to the furthest end of North Street and an eventual diversification into music sales. Another shop in North Street that also had a degree of longevity is Marks & Spencer's, associated with Chichester since the 1930s. However, their North Street shop is more recent, having been acquired from John Perrings, a furniture store, in the late 1970s.

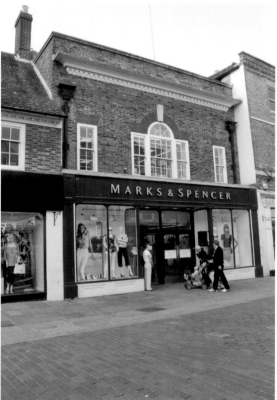

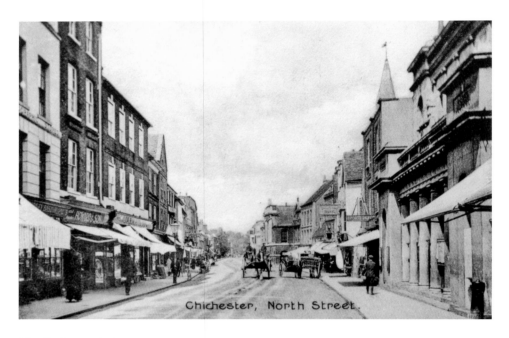

Chichester, North Street.

The Buttermarket

Originally known as the Market House, its purpose, when originally constructed in 1807, was to provide an enclosed trading area that would replace the Market Cross. The modern day interior view shows the building following an extensive period of renovation. Abigail Hooke (inset) is distributing flyers for Patisserie Valerie, the first trader to return to the Buttermarket following its reopening in March 2011. Rooms upstairs were also used by Chichester College of Technology for art lessons in the 1970s.

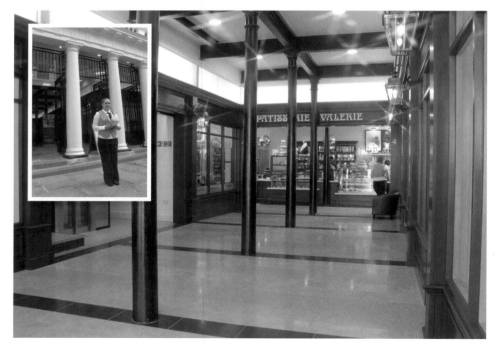

Foresters Arms

A late Victorian photograph of a once popular pub, the original building is still extant, located on the west side of North Street and opposite the George and Dragon pub. F. G. Hart was the publican up until the 1920s. Shortly after, the premises were acquired by Michael A. Guiarniccio, who ran it as a confectionary shop known to locals as 'Mickey's'. A short slim man, Mickey kept the money under the counter as he did not possess a till. Children found him particularly fascinating, as he would quickly slam onto the counter any pennies given in change. Mickey continued to run the shop into the 1970s. Currently, it is a small café and cake shop known as the Orchard Tea Rooms.

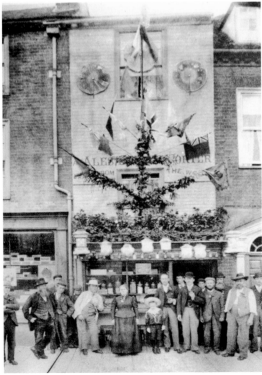

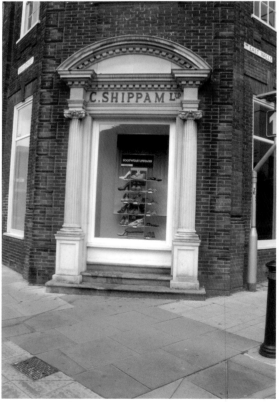

East Street

A shop owned by Charles Shippam, located at 51 East Street, sold directly to the public the produce of the nearby Shippam's factory, this located further along the same street. In particular Shippam's were famed for their meat pastes, originally sold in earthenware pots. However, by the time of this photograph, sometime around the 1930s, the paste was being sold in vacuum-sealed glass jars. Nowadays, the memory of the Shippam's presence as a major employer in the town centres upon the preservation of the ornate former entry doorway to the one-time factory building, together with an overhanging clock just above the same door.

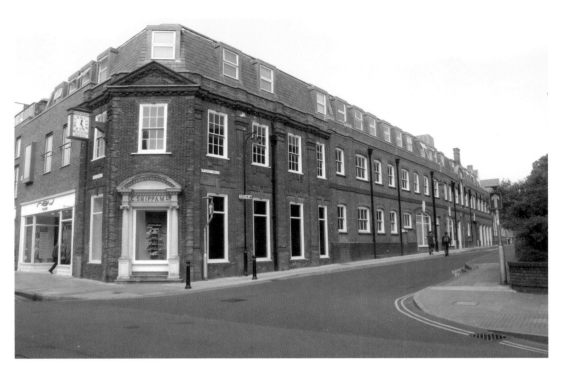

Shippam Limited

A general view of work underway in Shippam's East Walls factory, built shortly before the First World War. Here a range of food stuffs was prepared, including ox tongue, seen here being placed into glass moulds.

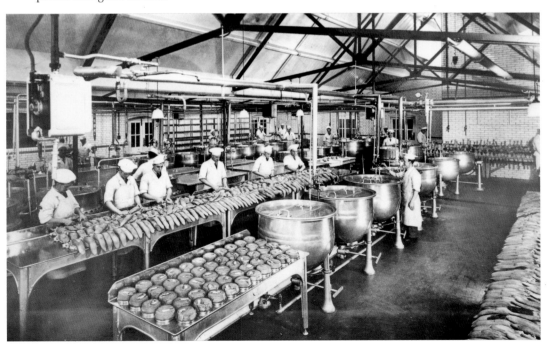

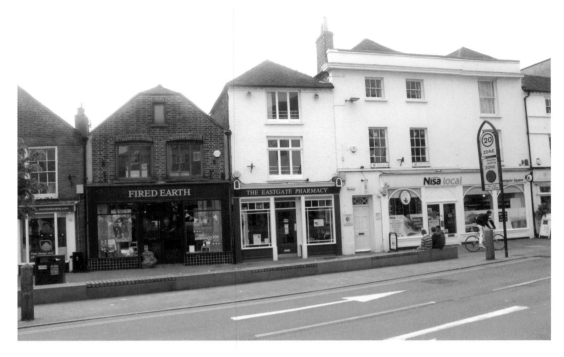

Eastgate Pharmacy

Eastgate Pharmacy was originally located on the right-hand side of the store named Nisa local, eventually taking over the whole of this same building before moving, in the 1990s, to its current position. This has resulted in a chemist shop having existed in this area of Eastgate Square for over 150 years. Samuel Baker, seen in the *c.* 1910 photograph, ran the shop until 1924. Subsequently the premises were taken over by George F. Beavis, who continued to run it as a chemist shop, while it is now the Eastgate Pharmacy.

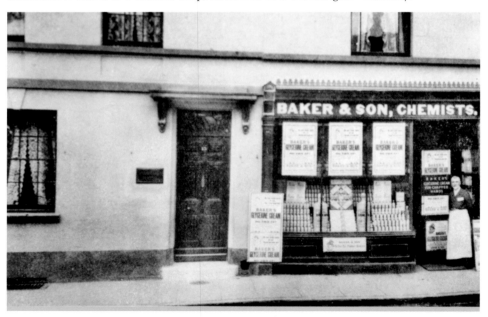

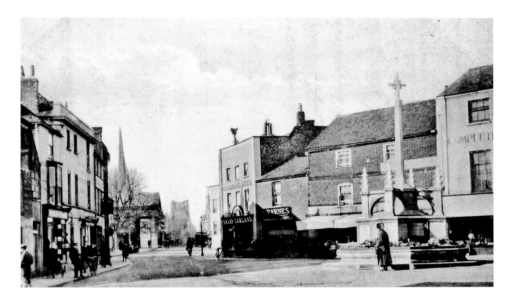

Eastgate Square

Eastgate Square was the original site of the city's war memorial before its removal to Litten Gardens (see page 46) shortly after the Second World War. Unveiled by Sir William Robertson, one of Field Marshal Haig's senior staff, the speech he made on the evening of 21 July 1921 referred to the huge amount of 'sorrow in many hearts' and went on to suggest that 'on every anniversary of that day or on armistice day, they should come to that monument and bring their children' for, in so doing, they would be showing 'honour to those great men'. Following the removal of the memorial, as can be seen in the more recent photograph, considerable redevelopment has taken place with the rounded building (Gordon House) standing on the site of the local swimming pool that had served local needs prior to the opening of the Westgate Centre in 1987.

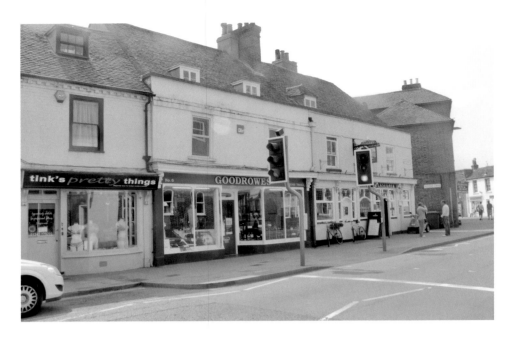

The Hornet

Henry J. Vokes is seen opening his new shop, 6 The Hornet, in April 1912. A bakery that included a tea garden, it was officially opened by Cllr. G. T. Apps of the Chichester City Council. The shop remained with the Vokes family until 1939. Sometime after that year, but prior to 1950, it was acquired by Goodrowe's Ltd, originally selling dairy machinery. Nowadays, however, it sells car parts. Another shop with an equally long history is the Eastgate Brewery, seen in both photographs (and in the modern on the right of Goodrowes).

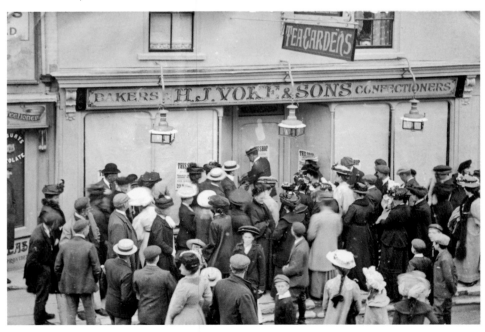

The Square

An interesting mix of new and old exists in the Eastgate Square area, the tower of St Pancras church being in the middle of a new development marketed as The Square. Although still an area rich in shops, none have the long-time connection with Chichester that was achieved by Goodger's, an outlet that formerly existed in the nearby Hornet. As the sales slip shows, the firm itself was first established in 1753. Much of the meat sold came from West Ashling, where the family possessed a considerable acreage of land.

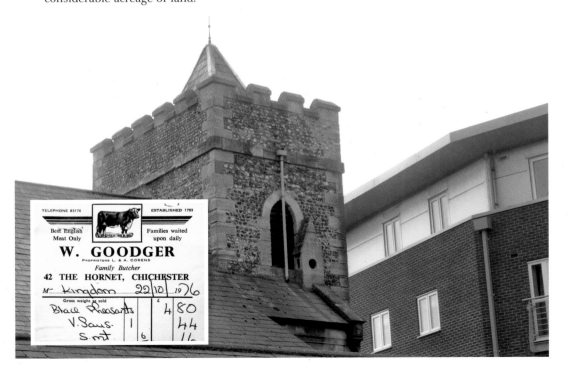

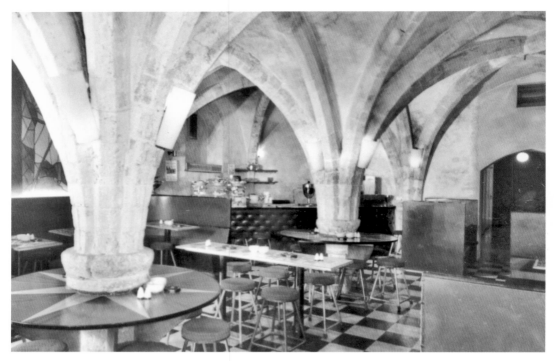

The Buttery

After all that shopping, time for a well-deserved break. The city is, and always has been, rich in its selection of small diners and bistros, with the Buttery in South Street, once known as The Crypt Coffee House, being among the more favoured. Its unusual internal layout results from the interior having been created from the basement of an early medieval building.

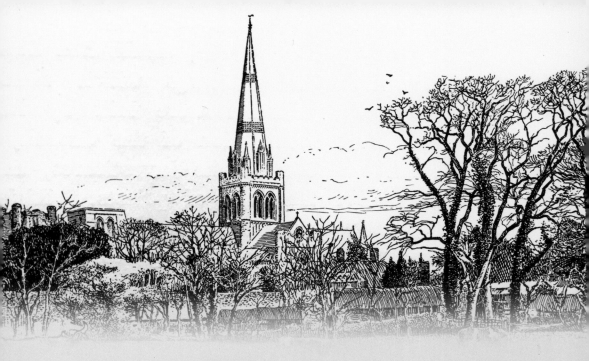

CHAPTER 2

The Spiritual Experience

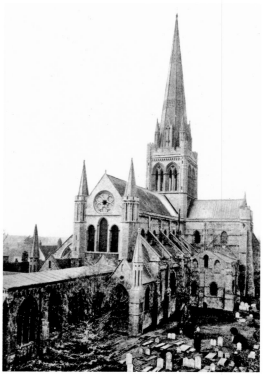

The Cathedral

Medieval Chichester was well served spiritually. The area of the city was divided into a number of separate parishes, each having its own church or place of prayer. The cathedral, of which the core building dates back to Norman times, originally served the needs of both a monastery and a parish church for those living within the parish of St Peter. On the previous page, where the cathedral is viewed from a distance, the drawing dates to about 1904, while the modern day view was taken from a similar point, but just inside the city walls rather than from outside.

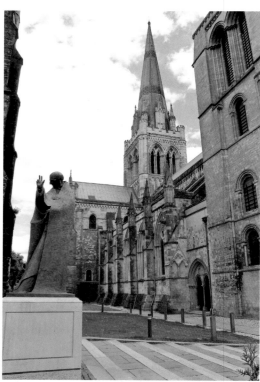

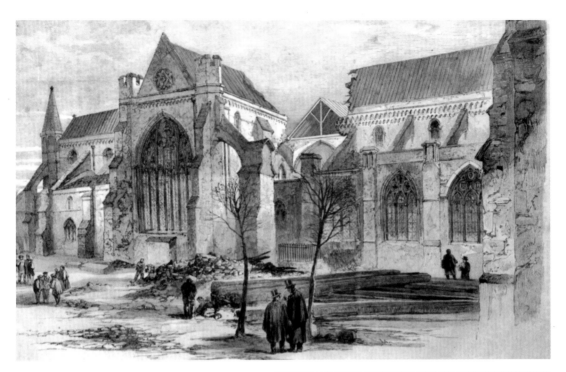

The New Tower

In February 1851, tragedy struck the cathedral when the central tower and spire collapsed. Caused by the weight of the tower, which had been heightened in the thirteenth century, it was an event that was only long delayed in its happening. Fortunately, it took place during a time when the building was empty, for if it happened during the time of a service, the outcome would surely have been unimaginable. Following the collapse, the present day tower and spire were constructed, with work completed in 1866.

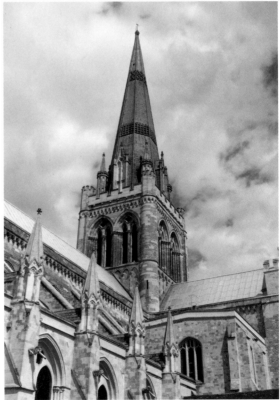

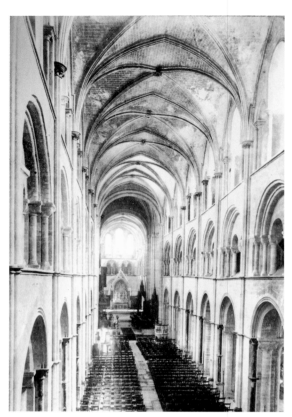

The Cathedral Nave
The nave as it appeared in the 1930s. It was during this decade, through the ministering of Bishop George Bell, that Chichester became a centre of the peace movement. Building on this, and serving as an icon of European unity, this important Anglo-German tapestry is sited behind the altar dedicated to St Richard.

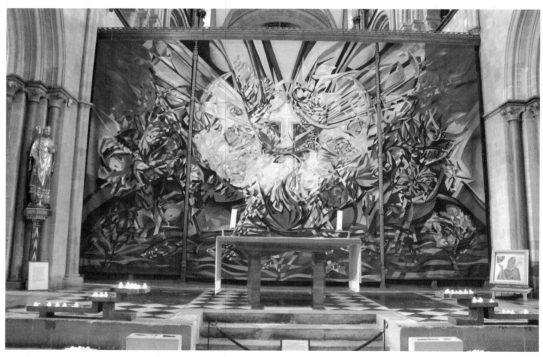

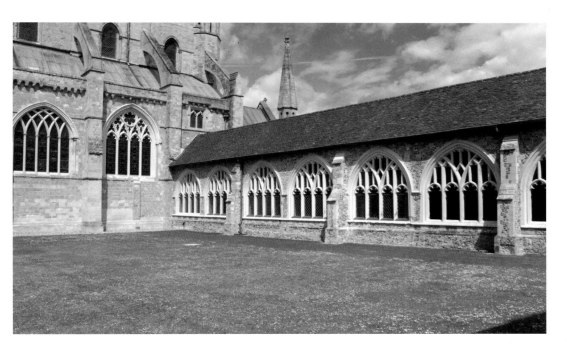

Cathedral Cloisters

The cloisters of the cathedral date to about the year 1400 and are in the medieval Decorated Gothic style. At one time, as can be seen from the earlier photograph, the cloisters provided space for a cemetery, with those who lived in the parish once served by the building being among those who were buried here.

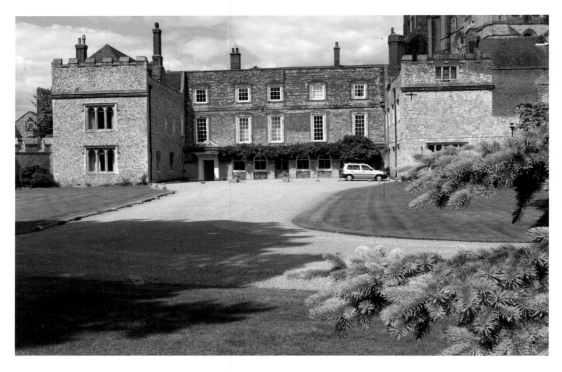

The Bishop's Palace
Serving as the residence of the Bishop of Chichester, this purely domestic building was originally laid out in the late twelfth century. Over the years it has undergone considerable re-modelling, with substantial later portions of the building dating to the thirteenth, fifteenth and sixteenth centuries.

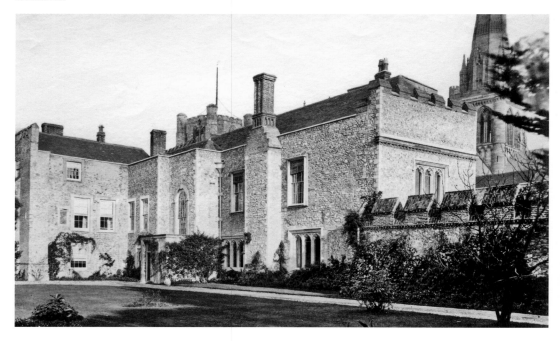

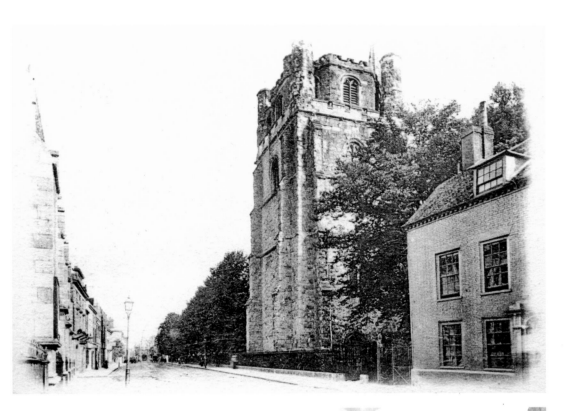

Bell Tower

A particularly distinctive feature of Chichester is the detached bell tower that stands alongside West Street. While many of the English medieval cathedrals once possessed such a feature, the one at Chichester is the only surviving example. Dating to the fourteenth century, it can by no means be described as attractive, but its uniqueness gives it an unrivalled historical significance.

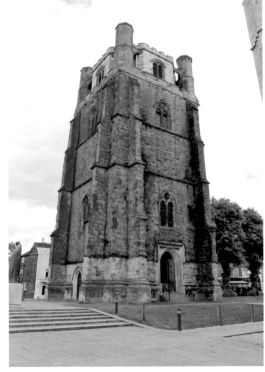

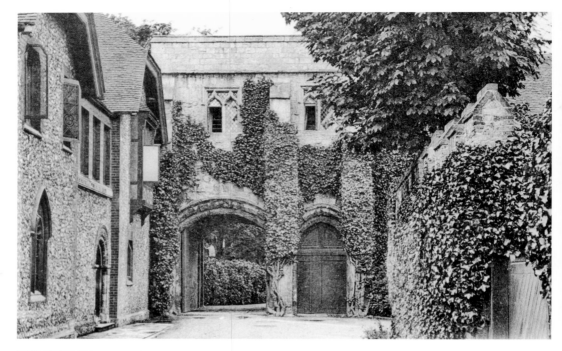

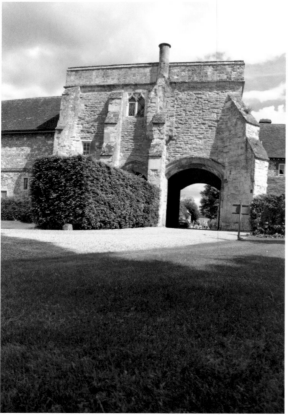

Gateway to the Bishop's Palace
In common with the Bell Tower, this structure also dates to the fourteenth century. Originally it was conceived as a means by which those of the cathedral could live a more exclusive lifestyle that would keep them from unnecessary contact with their troublesome secular neighbours.

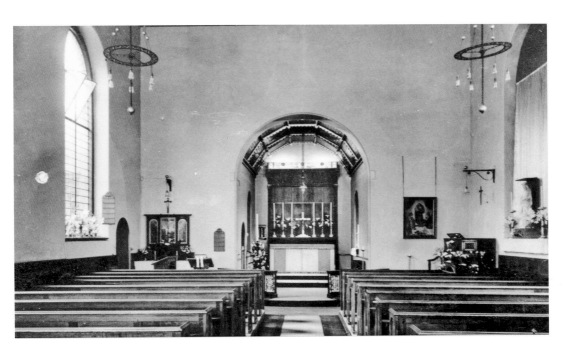

St Bartholomew

Situated in Mount Lane, the earlier photograph shows the nave of the church as it appeared during the inter-war period. The building itself is no longer a parish church, having become the Chaplaincy Centre for Chichester College. Following destruction of the original ancient round church during the English Civil War, the church was rebuilt between 1824 and 1832. This unduly lengthy building period was the result of a series of financial problems. At the time the earlier photograph was taken, St Bartholomew's was one of ten parish churches in Chichester and had seating for a congregation of 250 while allowing to the vicar £350 per annum.

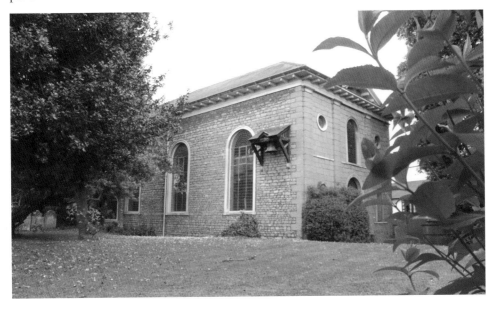

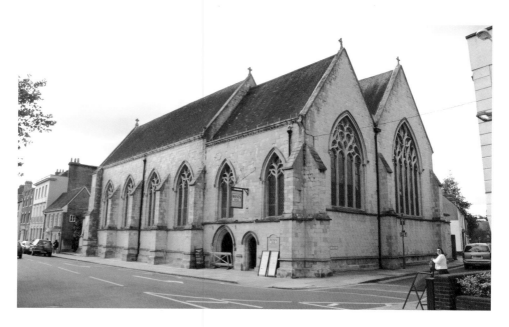

St Peter the Great

Also known as the Sub-Deanery, the church of St Peter the Great in West Street was the largest of the parish churches in Chichester, providing seating for a congregation of 600. With its foundation stone laid in August 1848, it is of the early Decorated style and was constructed to free the nearby cathedral of its parish duties, those who lived in the area served by the Sub-Deanery having once been accorded an altar within the cathedral. A dwindling congregation, and the need to carry out extensive repairs, led to the sale of the building in 1979. Currently a popular drinking venue, the two photographs provide an interesting contrast, with the one showing it shortly after completion as a church and the other as a present-day bar serving both alcohol and food.

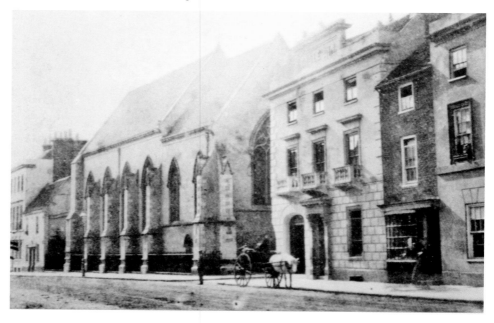

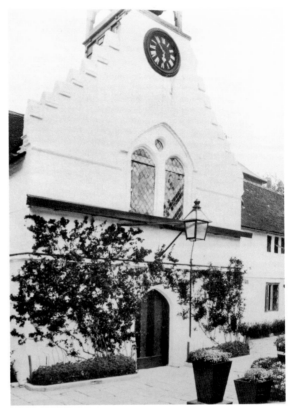

Chapel of St Bartholomew's Hospital
This exterior view of St Bartholomew's Hospital chapel in Broyle Road was taken sometime around 1909. In origin it was part of an almshouse for the maintenance of 'twelve decayed tradesmen' founded by Sir William Cawley in 1625. During the Civil War Sir William, who was at that time the Member of Parliament for Chichester, supported the Parliamentary cause, with his signature one of those placed on the death warrant of Charles I. The memorial to Sir William's father, John Cawley, is located in the cathedral and makes mention of the son, referring both to the almshouse he established and of his signing the king's death warrant.

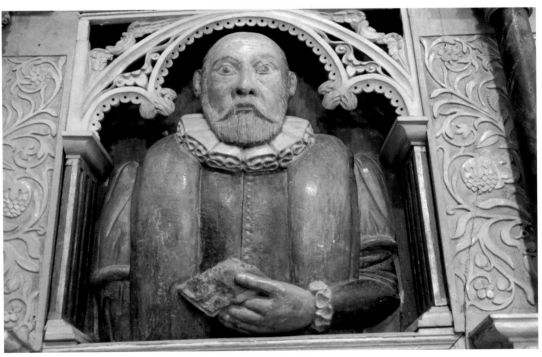

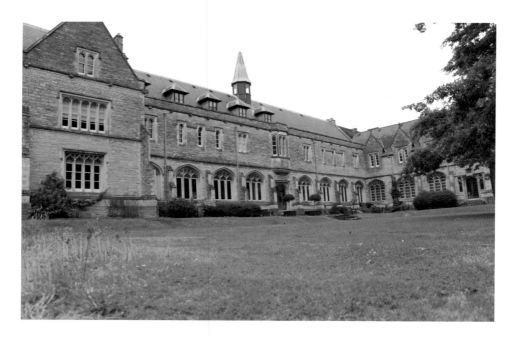

Bishop Otter College

Situated in College Lane, Bishop Otter College is now the site of Chichester University, having originally been established in 1840 as a training college for teachers. Bishop Otter himself had been greatly involved in education and the naming of this Church establishment was designed to serve as a permanent memorial to his name. It was in October 1850 that the College actually moved to its present site; it was re-styled as university in 1995, with many of the original buildings still in use. The Principal, staff and senior students of the College are seen here in June 1912, the doorway used as a backdrop in this photograph also to be seen in the centre of the modern-day picture.

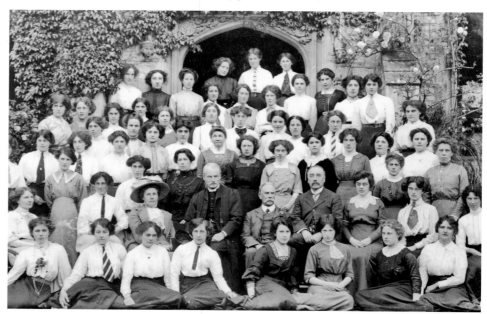

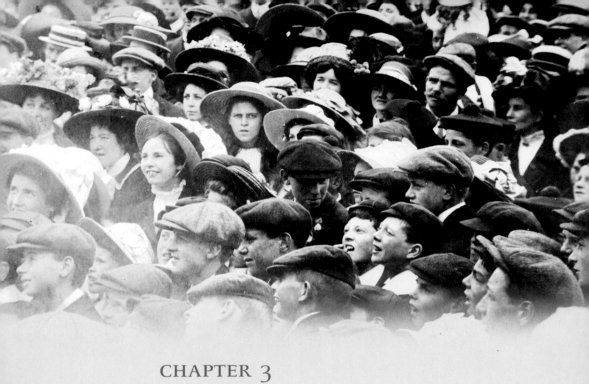

CHAPTER 3
Events & Celebrations

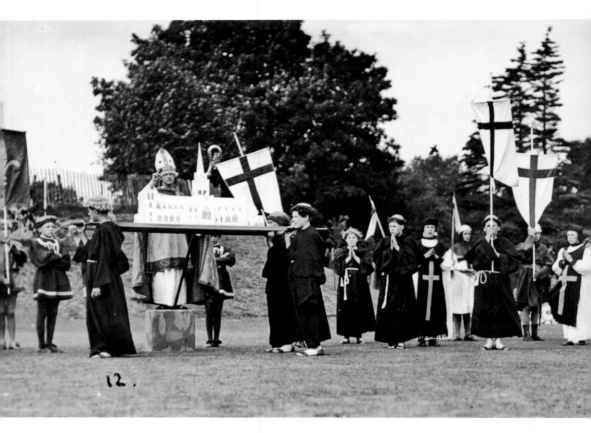

Summer Pageant of 1933

Events attract people – but no longer in the numbers that once seemed to be the case. The crowd depicted on the previous page were drawn to the festivities associated with the coronation of George V in 1911. Rarely, these days, does the centre of Chichester witness a similar density of people coming together for a single event. However, at nearby Goodwood, such numbers are quite usual, with the second picture on the previous page depicting some of those who collected for a recent super-smart Ladies' Day, always the last Thursday in July. On this page, a further example of a city-based open air event was the pageant held in Priory Park during the summer of 1933 concentrating on various aspects of the city's history.

Declaration of Elections

A further event that once attracted huge crowds was the declaration of election results which, at one time, were given from the balcony of the Council Rooms in North Street. Here, the returning officer is announcing the re-election of Edward Talbot, a Conservative who continued to hold the constituency until 1921, when he assumed the post of Lord Lieutenant of Ireland. Nowadays election announcements are much quieter, with the results given only to those who have gained a pass to the Westgate Leisure Centre.

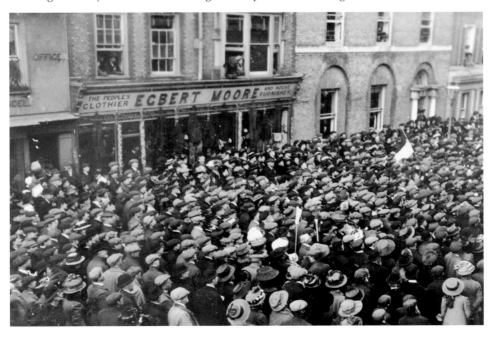

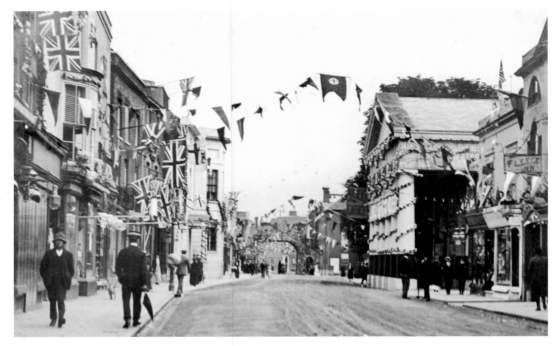

Royal Occasions

Huge celebrant crowds often appeared for royal occasions, with streets frequently decorated. Or at least that's how it used to be. For George V's coronation in 1911, flags were strung across all of the main streets. In contrast, and despite being a public holiday, the 2011 marriage of Prince William to Kate Middleton was much like an ordinary day, with only the occasional building reflecting this national event.

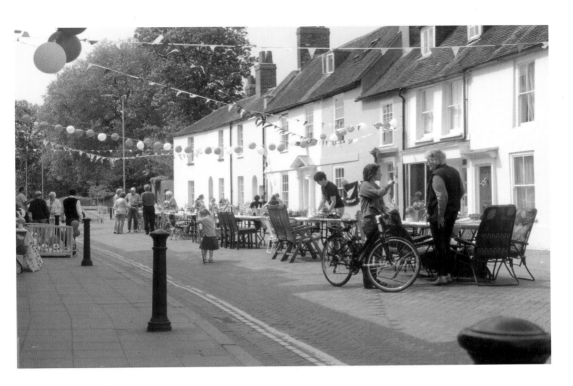

Street Parties

One of the few street parties held in Chichester to celebrate the royal wedding of 2011 was held in Westgate. Many more such parties were held in 1951, among them the families of Castleman Road.

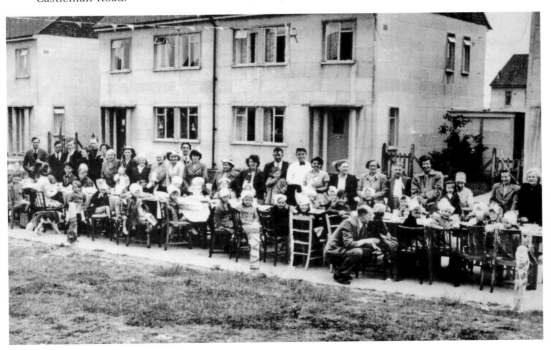

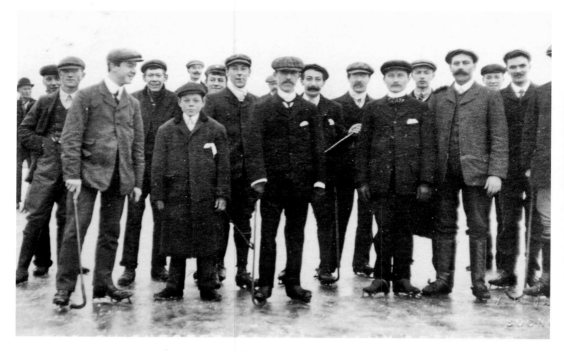

Ice Skating on the Canal!

The winter of 1906–07 was particularly cold, with temperatures plummeting on Sunday 27 January. In Chichester, these low temperatures not only ensured that the canal was frozen over, but that the ice was thick enough to allow a number of enthusiastic skaters to show off their talents.

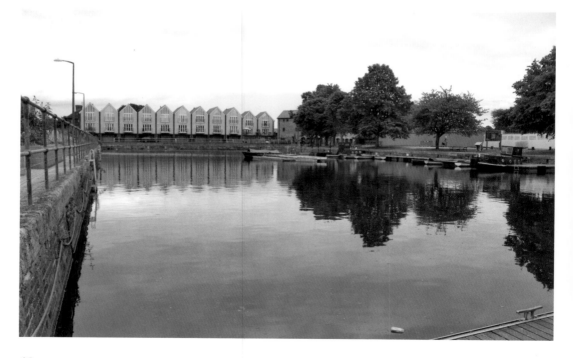

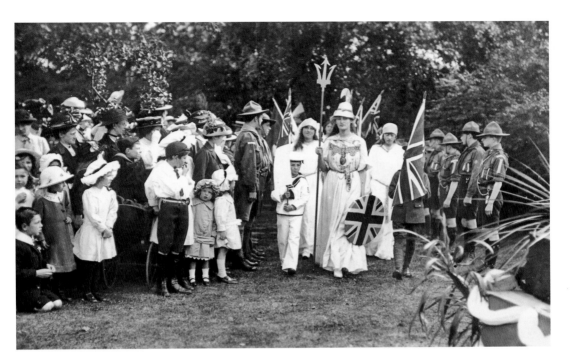

A Patriotic Endeavour

With the country in the depth and horrors of war, the summer of 1915 witnessed numerous open air pageants that had patriotism as their central theme. Chichester was no exception, with the one held in the Bishop's Garden being nothing less than a thinly disguised military recruiting campaign. Somewhat controversially, or at least by contemporary standards, the Anglican Church in the city was very keen to encourage parishioners to fight on the Western Front, with the clergy at all levels unhesitant in their encouragement of parishioners to get into uniform. In a Christmas 1914 sermon, the Bishop of Chichester, Dr Ridgeway, posed the question 'What then is our duty?' His answer, quite simply, was that 'we must be prepared to fight at any cost'. Another leading churchman of the city, the dean of the cathedral, would stand on a wagon as troops marched out of the city, beseeching them to go forward into battle. At the outset of the war, in August 1914, young men attending St George's church in Chichester were urged to ask themselves the question, 'Why am I not fighting on the front for my country?' If they could not give a good answer, they were told, 'The sooner you enlist the better'. Nowadays, the Bishop's Garden is as far removed from thoughts of war as might possibly be so.

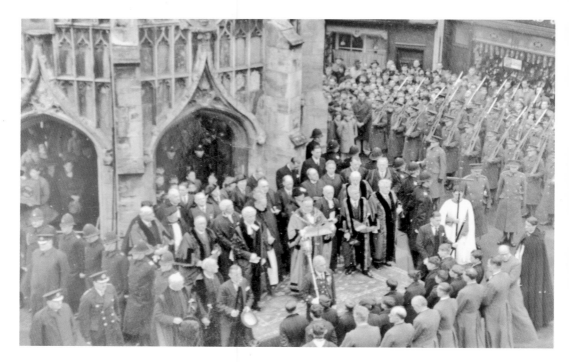

Mayoral Speeches

Chichester City Council, despite numerous changes in its authority, has been fortunate in retaining the office of mayor, an obvious figurehead able to represent the city on important occasions. The earlier picture shows the proclamation of George VI, read by the then-mayor, William Napper, at the Cross on 14 December 1936. The 'Redcaps' or Royal Military Police, in the modern-day photograph are seen marching towards the Council House during their 2011 'Freedom of the City' parade, where they were to be addressed by the serving mayor, Tony French.

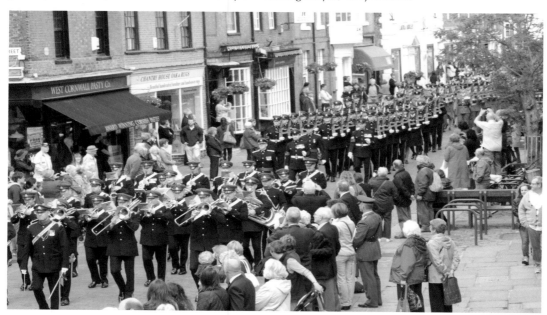

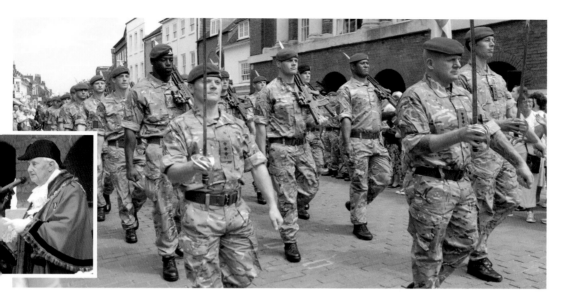

The Military Parade

Whether it's the Royal Military Police honouring their Freedom of the City, or other regiments formerly based at Chichester Barracks, military parades through Chichester have always been a common feature of life in the city. Judging by the style of clothing worn, the earlier parade dates to the immediate period prior to the Great War, while the more recent parade through the city took place on 5 July 2011, when medals from a tour of duty in Afghanistan were awarded to members of 21 Battery, 47 Regiment, Royal Artillery. The Mayor of Chichester, Tony French (inset) presented the medals and is seen here on the occasion of the awards ceremony making his concluding speech, in which he recognised the important work of a regiment that is currently based on nearby Thorney Island.

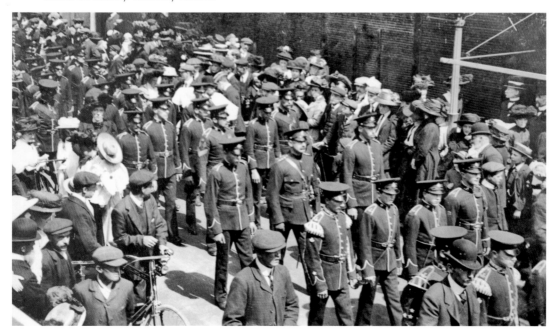

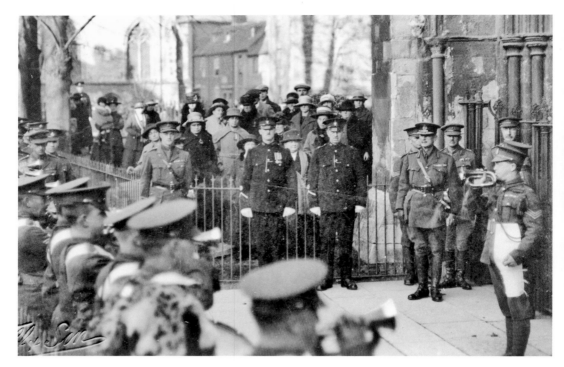

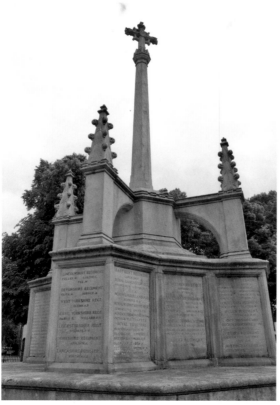

Remembrance Day

In pursuing its desire for peace and to not forget their fallen comrades, Armistice Day in Chichester was an important occasion of remembrance. Here, members of the Sussex Regiment are attending a special cathedral service. The Armistice Day of November 1923 in Chichester was recorded by the local paper in the following terms, 'Two minutes – and what memories and what thoughts were crowded in to that brief space of time! As one stood erect with one's thoughts resting reverently on the memory of that great Army that lay in Flanders fields, one could not help wondering what effect the silence had elsewhere.' A separate service was also regularly held, following its unveiling in 1921, at the war memorial in Eastgate Square (see page 21). This memorial has now been moved to Litten Gardens.

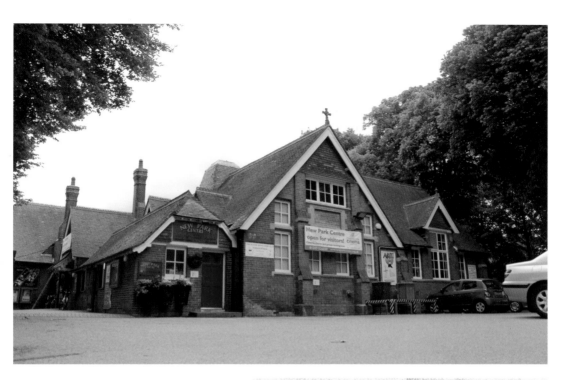

Ad Hoc Theatres

During the inter-war years, Chichester lacked a dedicated theatre. On occasions, the Corn Exchange served as an *ad hoc* theatre, being also one of several local cinemas. During the late winter of 1922, it presented two plays, *The Sorcerer* and *Trial by Jury*. Nowadays, the city has a dedicated theatre, the Festival Theatre which first opened in July 1962. Nowadays, the role of *ad hoc* theatre is played out by the New Park Cinema in New Park Road.

"The Sorcerer"

. . and . .

"Trial by Jury"

—— PRESENTED AT THE ——

CORN EXCHANGE,
:: CHICHESTER, ::

Tuesday, Wednesday, Thursday, Friday and Saturday

Nov. 28th to Dec. 2nd, 1922,

At 7.30 p.m.

MATINEE THURSDAY, NOVEMBER 30TH, AT 2.30.

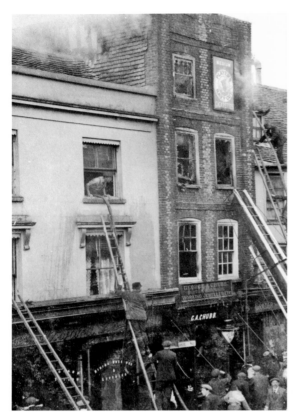

Fire!

A dramatic fire that broke out in Chichester on 16 June 1910 was dealt with both by the local fire brigade and a number of by-standers. At that time the fire station was located close to the present day Market car park, while today it stands in Northgate.

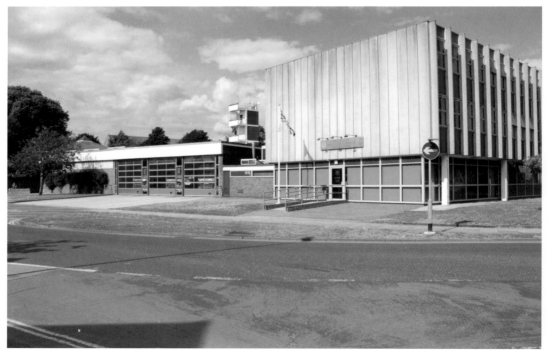

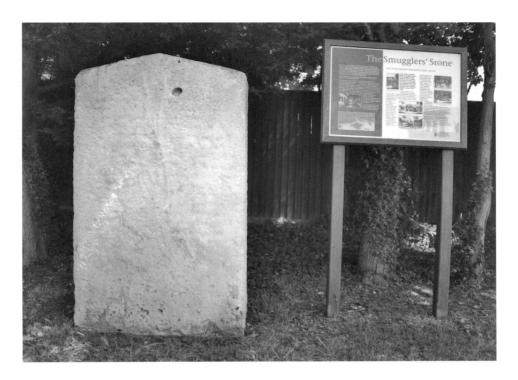

Smugglers' Stone

Two horrific murders carried out by a local gang of smugglers led to the execution of several members of the gang, these hangings taking place in 1749. Gallows were erected on the Broyle for the purpose, with the site subsequently marked by a specially inscribed stone to deter others. The writing on the stone is no longer discernible, with an explanation of the origin of the stone provided by an adjoining information board.

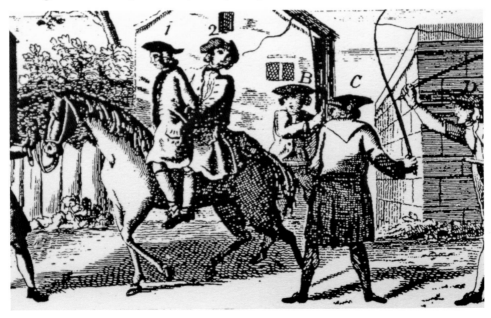

Funeral of Dr Wilberforce
In September 1907 the funeral of
Dr Ernest Roland Wilberforce, Bishop
of Chichester for nearly twelve years,
was undertaken. The memorial stands
on the north side of the cathedral nave,
with Dr Wilberforce buried in nearby
Westhampnett.

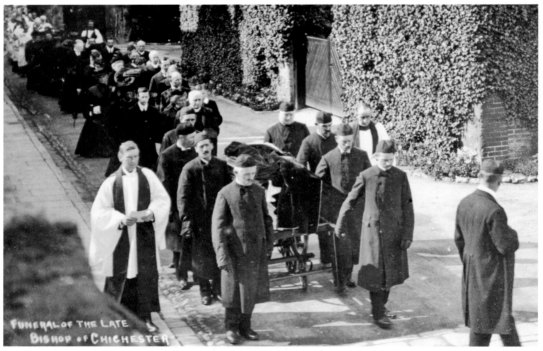

FUNERAL OF THE LATE
BISHOP OF CHICHESTER

CHAPTER 4

Notable Buildings

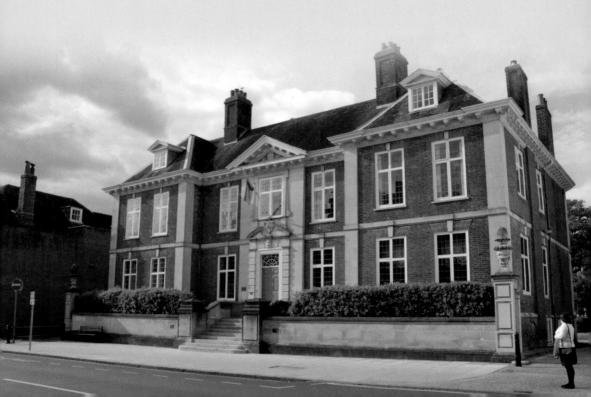

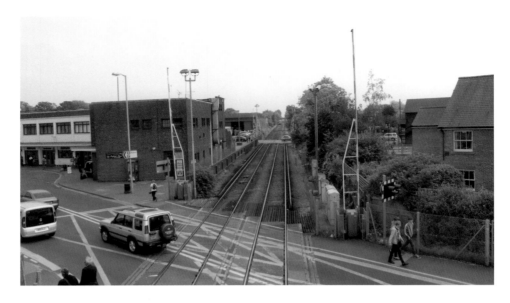

County Town

Previous page: two views of Ede's House separated by more than sixty years. Now owned by West Sussex County Council and fronting County Hall, Ede's House (originally Westgate House) was built in 1696 for John and Hannah Edes.

This page: The earlier photograph is of the original police station at Southgate that served the county force until the move to Kingsham Road in 1931. As for the site upon which the earlier building had stood, this is now an extension to the bus station. When originally built, this first county station in the city served only as a sub-station, with the county constabulary's main building situated in Petworth. Officially opened in March 1860, local newspaper reporters were given the opportunity to inspect the Southgate building, the *West Sussex Gazette* noting that it was 'well adapted for the purpose, includes six cells, a strong room, a guard room, an office for the superintendent, and residence for the same, and a residence for a constable with a single man lodger, and all the necessary outbuildings of coach house, stable, hay loft &tc'.

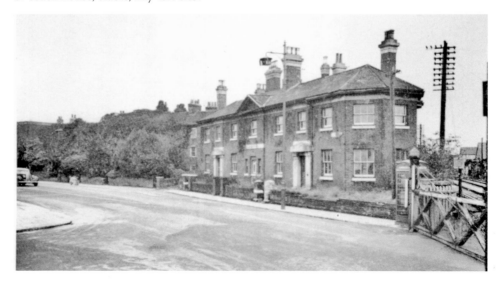

Chichester Police Station

While the new rural force was based in Southgate, an earlier Corporation of Chichester constabulary, formed in 1836, had a separate building, this located in Eastgate. The earlier photograph shows this station and one which continued to be used until the merging of the city force with that of the rural constabulary in 1858. Eventually, the Southgate building, which had become both the West Sussex Police Headquarters and the Chichester Divisional Headquarters, had to be replaced, with construction starting in 1931 on a new building situated on the corner of Kingsham Road and fronting onto Basin Road.

In 1857, following the creation of a separate rural constabulary in West Sussex, a second police station was built in Chichester, this to serve only the needs of this new body. Constructed on a piece of land in Southgate (the site of the present-day bus station), it served as a sub-station.

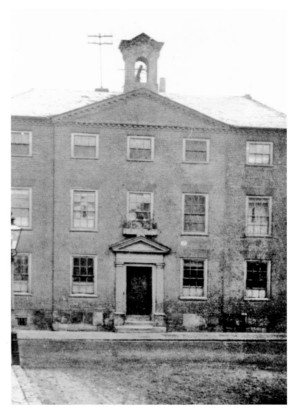

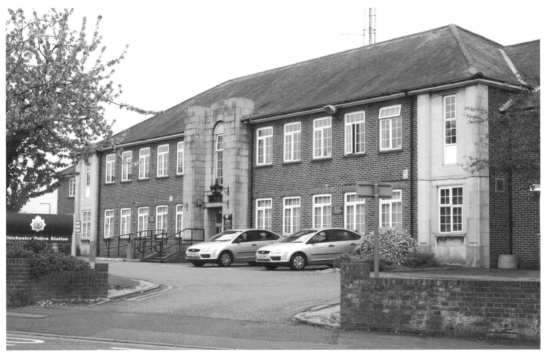

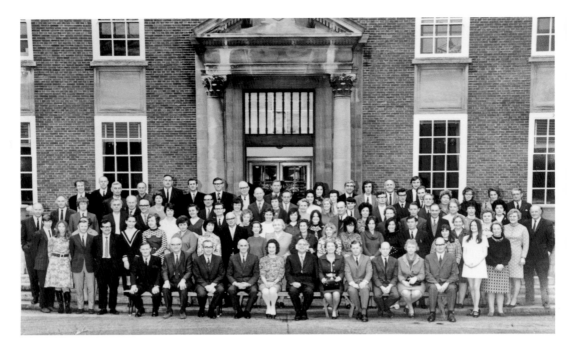

County Hall
Prior to the building of County Hall in 1936, Ede's House had served the purpose of providing office space for use by the County. Grouped in front of County Hall, in 1971, are members of the Department of Education, brought together for the retirement of the outgoing Director of Education, Dr Cyril W. Read. The modern-day view of County Hall also shows a rather unusual flower bed in the foreground, this created from a static water tank put there immediately before the outbreak of war in 1939.

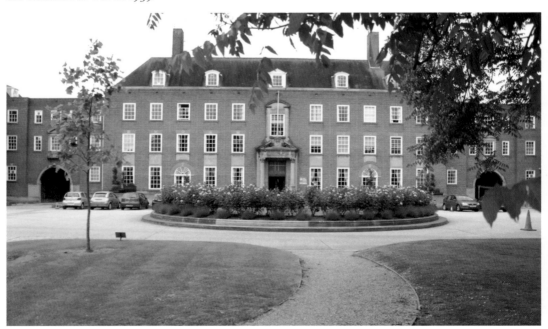

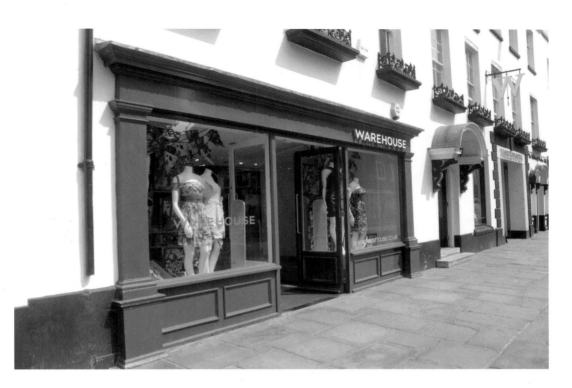

The Dolphin & Anchor

The Dolphin & Anchor were two separate inns that were combined in 1910. Originally the Dolphin was a coaching inn that, as far as the current building is concerned, dates to a rebuilding that took place in 1768. In more recent years, the part of the building that was the Dolphin has been converted into separate retail outlets, Warehouse being one that was established there in 2005.

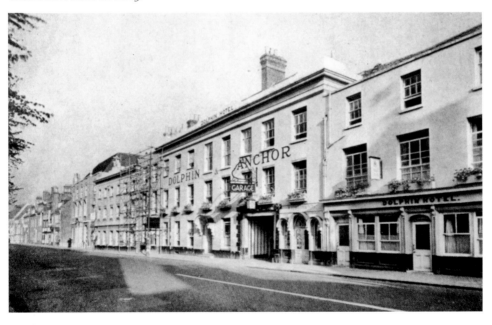

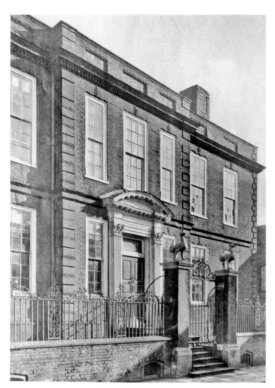

Pallant House
Dating to 1712, and occasionally referred to as Dodo House because of the peculiarity of the birds that sit astride the gateway piers, Pallant is a seven-bayed house that now serves as an art gallery. The house itself lies at the heart of the Pallants, the virtually unchanged Georgian heart of Chichester. In the more recent photograph, a selection of Georgian houses can be seen stretching the length of East Pallant.

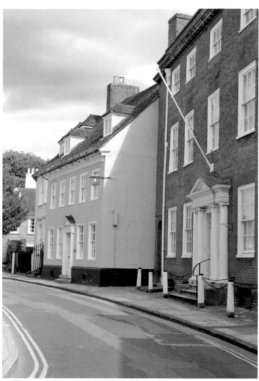

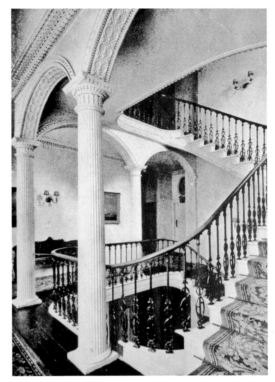

Ship Hotel

In North Street is the Ship Hotel, built by Admiral Sir George Murray sometime around 1790. Of particular interest is a fine internal staircase in the style of Adam, seen here in a photograph taken during the middle years of the twentieth century. Murray was a noted naval officer who fought alongside Nelson at the Battle of Copenhagen.

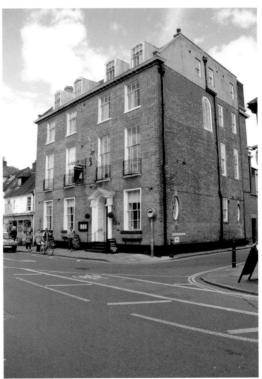

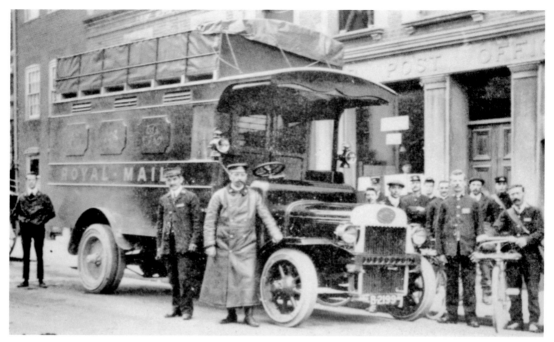

Post Office in West Street

Here, the South Street post office is to be glimpsed behind a Royal Mail delivery van, with the photograph probably taken during the first decade of the twentieth century. As can be seen from the date stone above the present day post office in West Street, it is a building that dates to 1937. On this occasion the door is shut, but when open it is a building characterised by long queues due to an excessive amount of time required to reach one of the serving hatches.

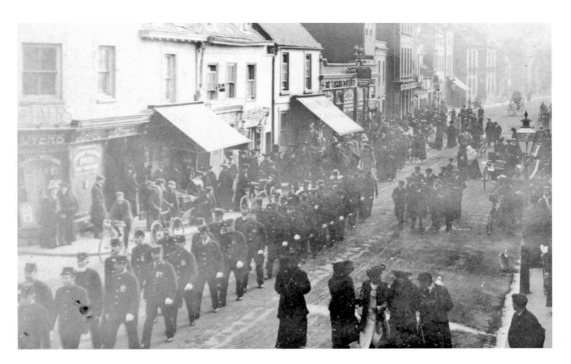

Post Office in South Street

It might not be a post office now, but this building in South Street (No. 52), home to a travel company, was the original main post office prior to its move to West Street in 1937. Those who worked for the Post Office had great pride in the organisation and the uniform they wore. In many ways, it attempted to replicate the military in its organisational efficiency and carefully honed discipline. Proof of this can be seen by this impressive march by post office employees, captured in this picture as they pass outside the post office building in South Street.

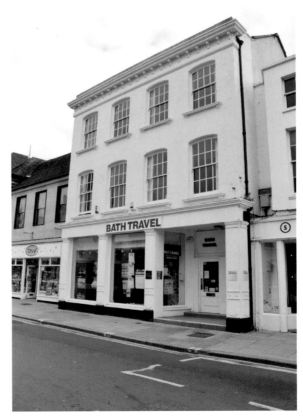

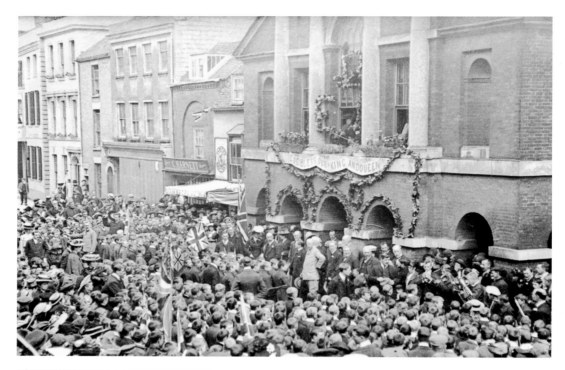

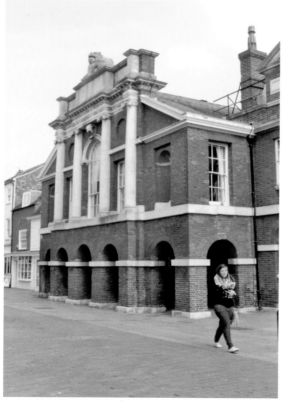

Council House

The Council House in North Street was built between 1729 and 1733 and was designed to serve as the venue for meetings of the Corporation, the elected governing body of the city. Occasions, both formal and celebratory were often centred upon the Council House, with huge crowds often assembling to hear either speeches or election results. One such event is depicted: the assembly of school children and older residents on Empire Day, 1907, brought to the Council House where, following a series of patriotic speeches, singing was accompanied by a specially assembled brass band.

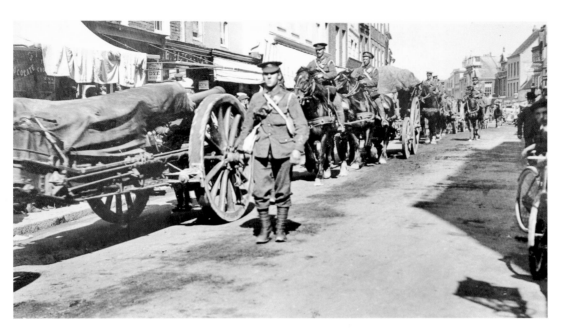

Chichester Barracks

Initially constructed in 1795, the Barracks in Broyle Road have undergone several periods of enlargement prior to a final closure and conversion into a residential estate. Home to various regiments throughout its years of military service, members of the Royal West Sussex Regiment, having left the barracks earlier in the day, proceed through North Street destined for the summer manoeuvres encampment.

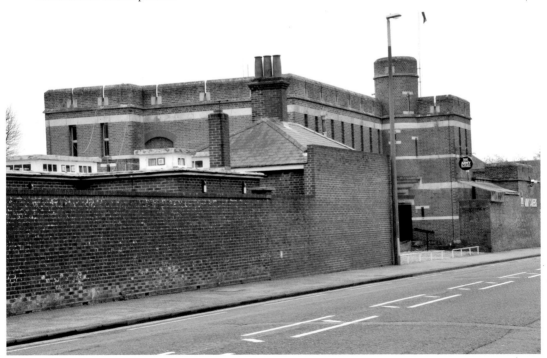

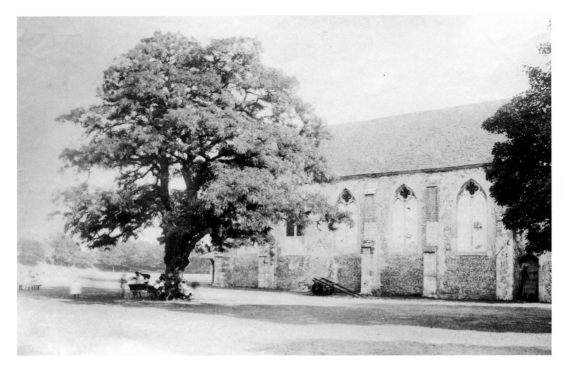

Guildhall

Two views of the Guildhall in Priory Park, with the earlier photograph dating to the reign of Queen Victoria. The Guildhall itself is the only surviving section of a former Franciscan friary that dates to the thirteenth century. Following the dissolution of religious houses by Henry VIII, the building was given to the Mayor and citizens of Chichester and subsequently used for a variety of purposes, including that of a court house.

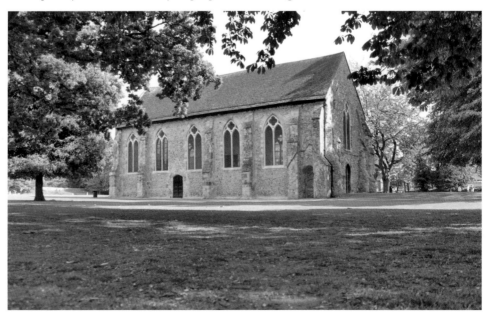

Chichester Steam Laundry

Less a notable building and more the site of a tragedy, the steam laundry building was heavily damaged in 1944 when a four-engine Liberator bomber crashed onto the site. The earlier photograph is of laundry employees during happier times, while the other shows part of the Hornet, where further damage was sustained by the engines that broke away from the main fuselage and wings.

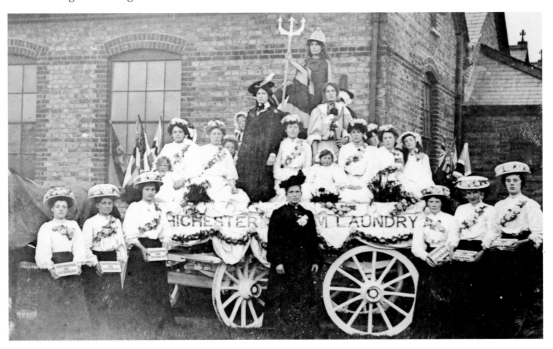

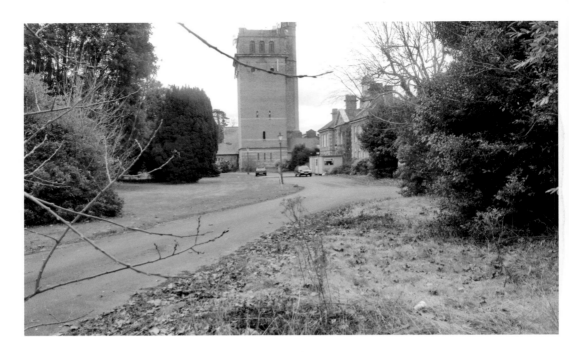

Graylingwell Hospital

Officially opened in 1897 as a West Sussex County Asylum, Graylingwell Hospital was designed by Robert Lloyd to accommodate those with severe mental health problems. During the First World War, and recalled by the earlier photograph, the hospital was taken over by the military and provided care for those wounded on the Western Front. Now closed, the site is undergoing redevelopment, with this view showing the former water tower.

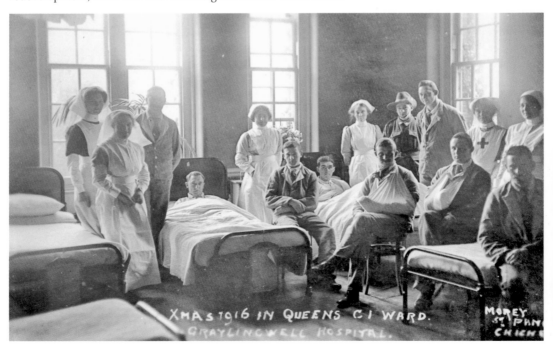

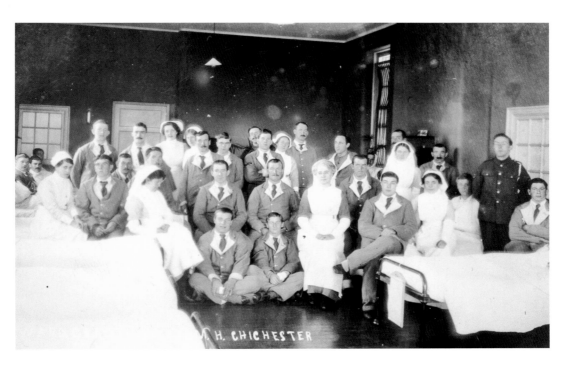

North Lodge

Standing at one of the entry lanes into Graylingwell Hospital, North Lodge, seen here on the verge of demolition, was occupied by the steward of the hospital. Again, a view of one of the hospital wards is given, and at a time when it was occupied by those who had been injured during the Great War.

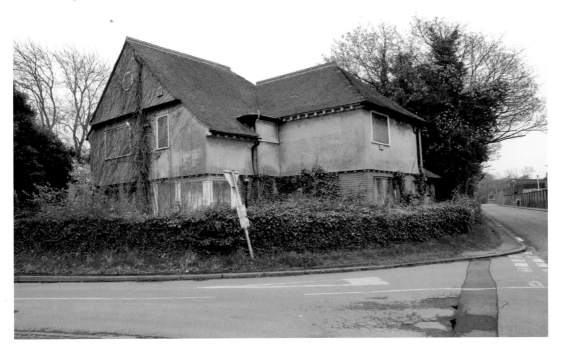

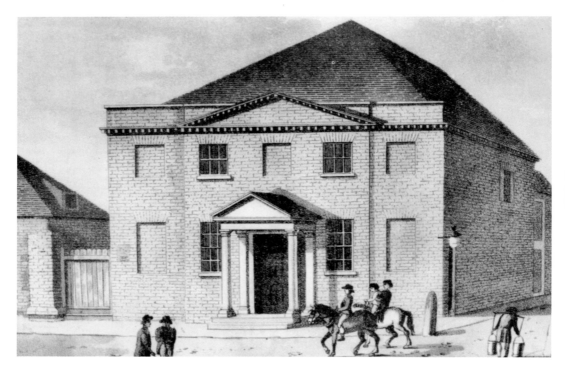

Chichester Theatre

A building of especial importance for the history of Chichester is a small building, now a restaurant, on the corner of South Street and Theatre Lane. As originally constructed, this was a purpose-built theatre that first opened its doors in May 1792 with a performance of *The Siege of Belgrade*. Contrast this one-time small theatre with the much later Festival Theatre (inset) that opened in Chichester 170 years later.

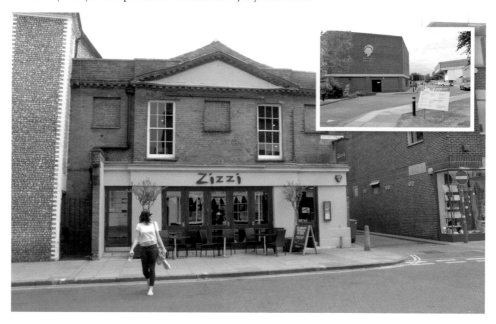

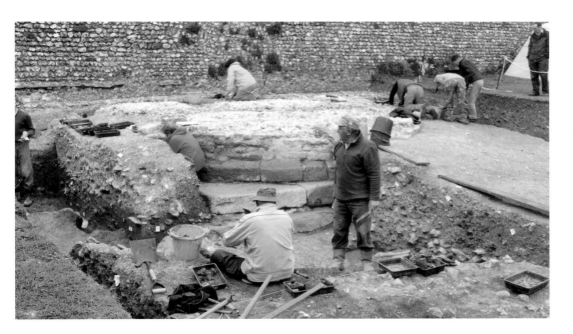

City Walls

The city walls date to Roman times and were pierced with gates at each of the four cardinal points of the compass. Due to various road widening schemes over the passing centuries, these gates have long since ceased to exist, although attempts were made to replicate these gates as part of the celebrations held for the coronation of George V (1911). The modern-day photograph shows an archaeological exploration that took place in 2010 and the uncovering of the base of one of the numerous towers that made up the original wall.

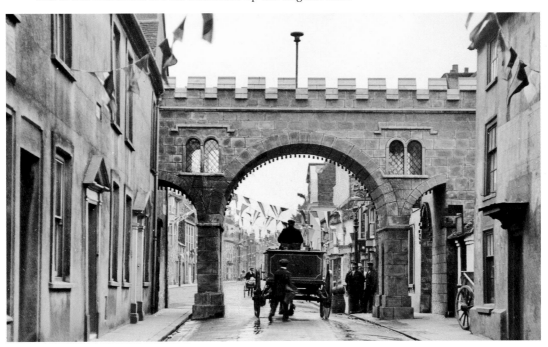

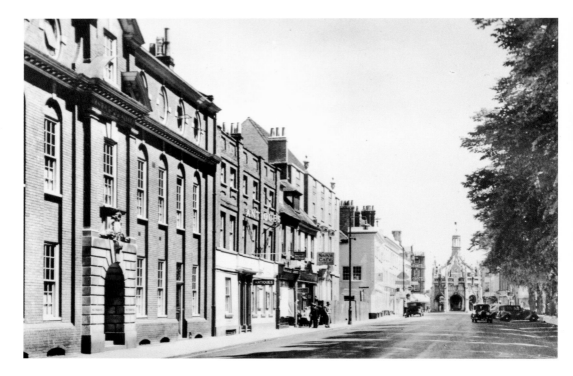

Oliver Whitby School

An early eighteenth-century addition to the city was the Oliver Whitby School in West Street. However, the present day building dates to 1904 with the school closing in 1949. Since that date, the original building has been acquired as a retail outlet with the modern day view depicting the original entrance to the school. For a more general view of how the former Oliver Whitby School building is currently used, see page 10.

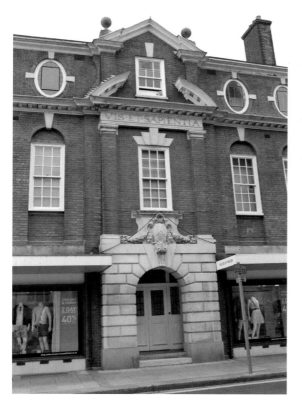

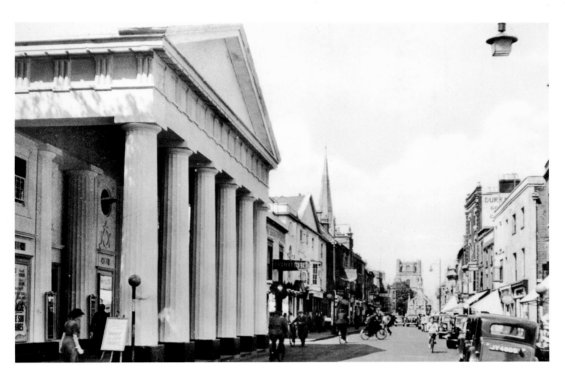

Corn Exchange

Among the most impressive of the
city buildings is the Corn Exchange,
located at the far end of East Street.
Completed in 1833, it was designed
as a public market for easing the
transaction of locally harvested corn.
Samples were held in various pitchers,
allowing bidders to gain a sample of
the quality of the produce they were
to purchase. In the earlier of these
two photographs, probably taken in
1946, and helping provide a date, is the
outside A-board that informs passers-
by that the film being shown is *When
the Sun Shines*, best described as a mild
wartime comedy. In later years, the
Corn Exchange was to become a fast
food venue before its current use as a
clothing retail outlet.

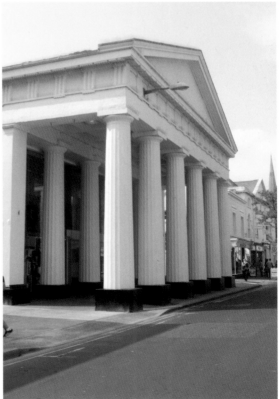

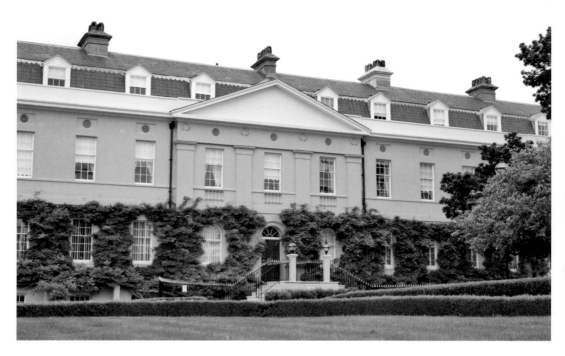

Royal West Sussex Hospital

Following a scheme of modernisation and enlargement, the Royal West Sussex Hospital, which was originally completed in 1826, was officially reopened by George V in 1926. Although no longer a hospital, the main building survives having been converted into private residences.

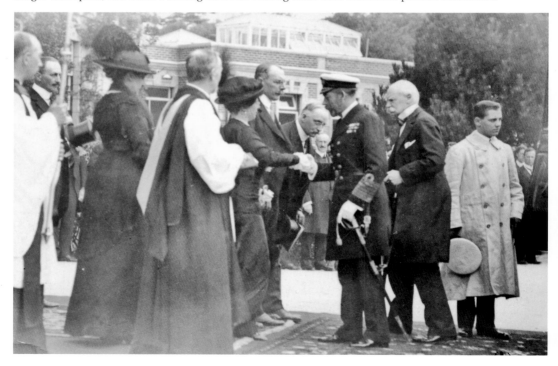

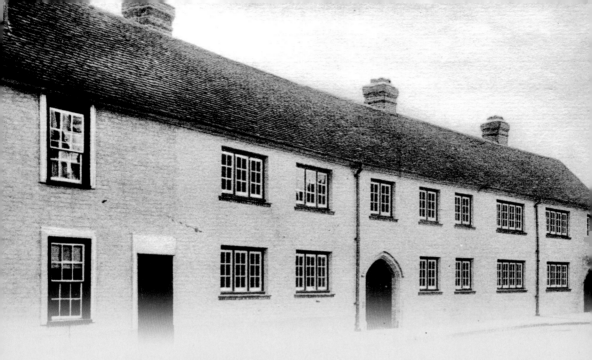

CHAPTER 5

Home Sweet Home

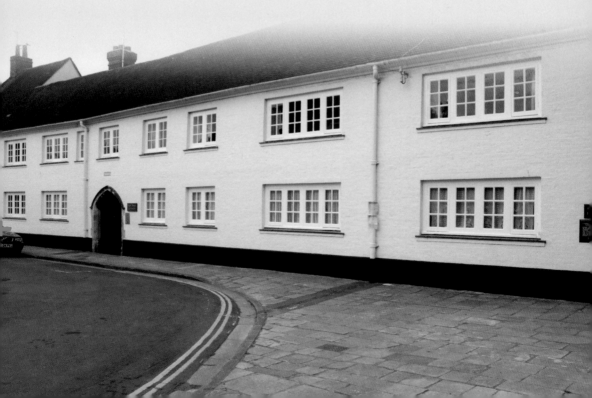

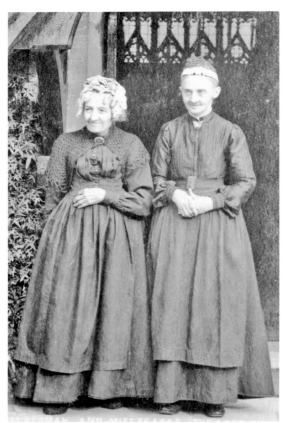

St Mary's Hospital Almshouse
Situated in St Martin's Square are a group of houses that are part of the St Mary's Hospital Almshouse complex. The complex has existed in this area of Chichester since the thirteenth century, having been established for the care of the sick and for those in poverty who need overnight accommodation. By the sixteenth century this role had altered to that of providing permanent rather than temporary care, with housing given over to the elderly who had little means of support. The houses viewed on the previous page are four cottages that were converted into married quarters in 1905. A particular building of importance which stands within the complex is a thirteenth-century barn-like structure that, during the seventeenth century, was converted into eight single bedroom flats. On this page, two of the permanent residents of the complex, Miss Redman and Miss Pearce, are seen on the occasion of being presented to King Edward VII at the time of one of two visits he made to the Almshouse complex, these being in 1906 and 1908.

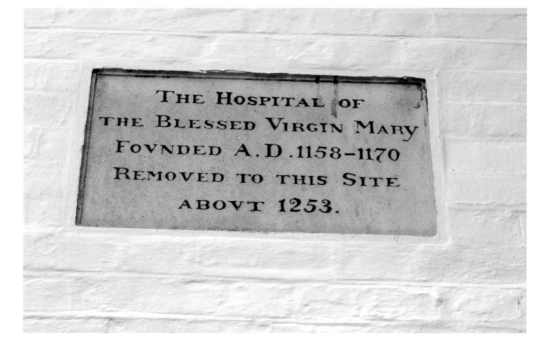

THE HOSPITAL OF
THE BLESSED VIRGIN MARY
FOVNDED A.D.1158–1170
REMOVED TO THIS SITE
ABOVT 1253.

Crooked 'S'

Distinctly down-market at the outset of the twentieth century, the Crooked 'S' off North Street was once a narrow passage that gave access to a number of small and cheap homes. While the passageway still exists, and it is possible to see where the original doorways and windows once stood, the buildings lining this passageway are used as extensions or storage areas for nearby business premises.

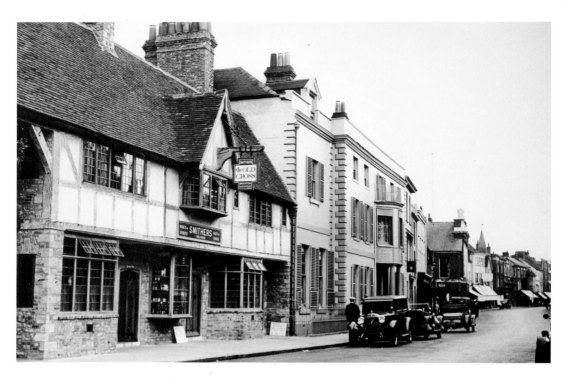

The Old Cross

Following a fire on this site, the present building was constructed in 1928. Admittedly it gives the appearance of having been built in Tudor times, but this is far from being so. The building further along, the North House Hotel, was itself replaced by a new building in 1936.

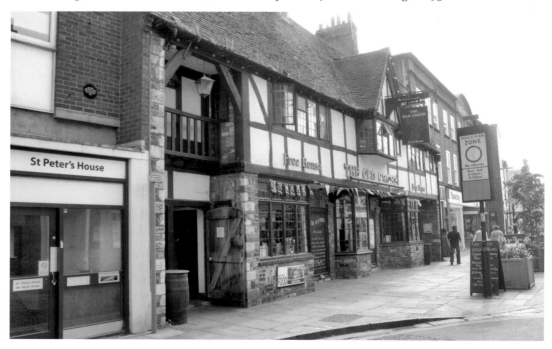

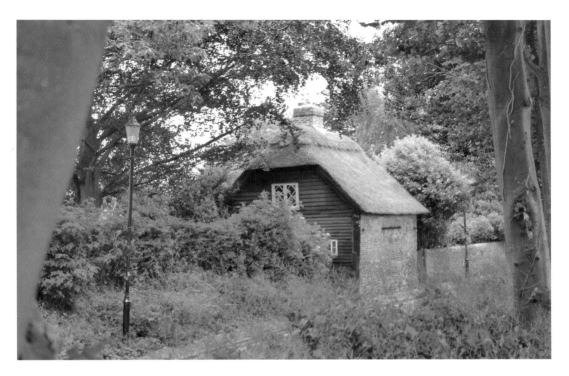

Love Lane

Once a quiet road with a few residential houses along its length, it is now a somewhat busy 'country' lane that gives access to the university. However, the original thatched cottage, on the edge of the university grounds, still exists. Oh, and the road itself is now College Lane.

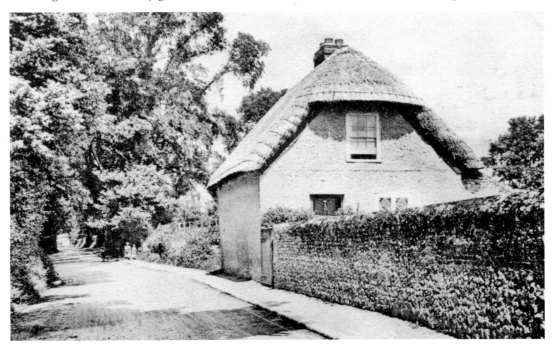

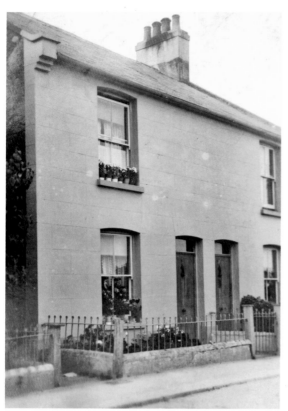

Homes Fit for Heroes

Following the ending of the First World War, a call went out for the building of homes suitable for those who had given so much during their country's time of need. Although never fully carried through, efforts in Chichester led to the rapid construction of a number of small houses, these heavily reliant upon concrete to allow for more rapid construction, and a number of these are located in Pound Farm Road and viewed in the modern day picture. The earlier photograph shows a not dissimilar group of artisan houses photographed during the 1920s.

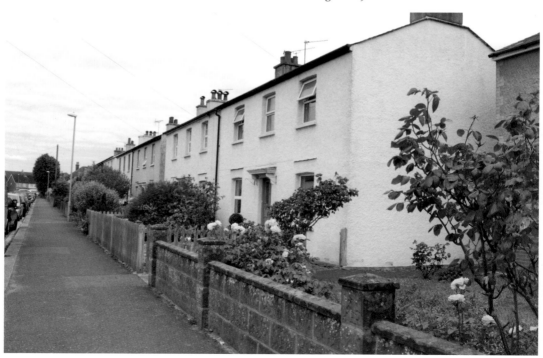

CHAPTER 6

Time Out

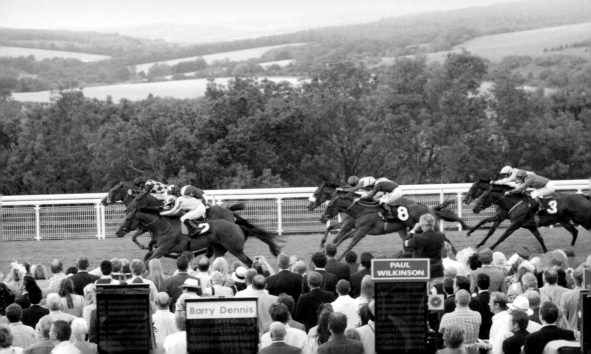

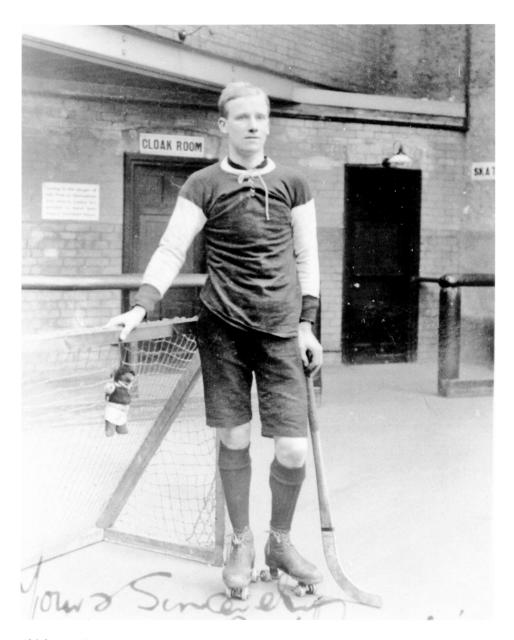

Chichester Sports

On the previous page, a scene of perfect harmony: bookies, runners, bright sunshine, an enthusiastic crowd and beautiful countryside. Can this be anywhere else than 'Glorious Goodwood'? For over two hundred years, the race track has been drawing Cicestrians to this nearby racing venue, once an important round in the high society annual calendar. In contrast to the Sport of Kings was the craze of roller skating that took the city by storm during the early decades of the twentieth century. Bert Furniss, one of the stars of the Chichester roller skating hockey team, is seen in the specially constructed arena in Northgate which opened on 23 May 1910. The rink itself was owned by Chichester Olympia Ltd, with the company going on to open a cinema on land that immediately adjoined the rink.

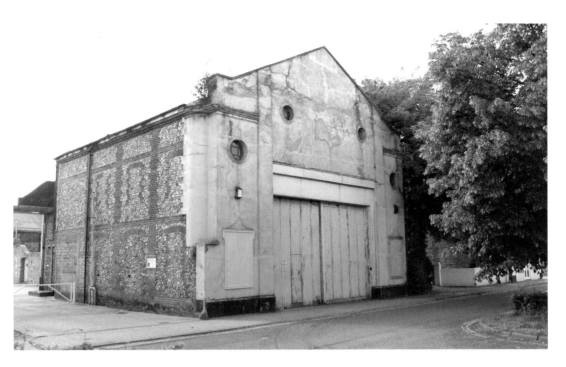

Olympia Skating Rink

Fellow members of the local Chichester hockey team join Bert Furniss (centre right) for another photograph. The adjoining Olympia cinema building still exists, albeit in a deteriorating condition on an isolated roundabout site, with the entrance to the long abandoned rink on the immediate left of this building. The Olympia cinema was opened in 1911 and closed in February 1922 following a fire.

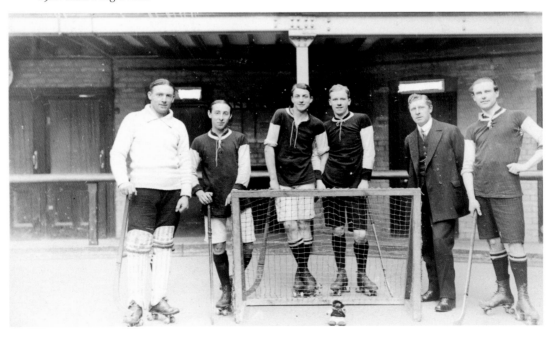

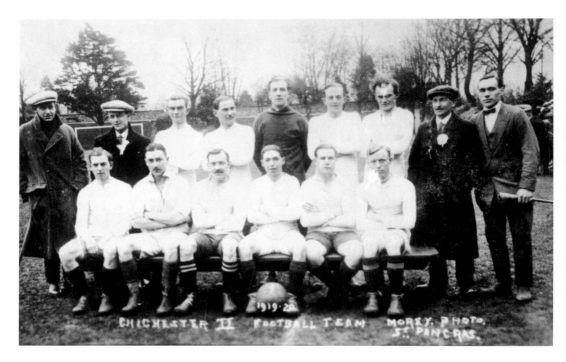

Chichester City Football Club

The present day club, Chichester United, was established in 2000 following a merger between the city's two senior non-league football clubs, Chichester and Portfield, with the team playing in the Sussex League. The earlier photograph shows members of the original Chichester City club, seen here at the beginning of the 1919–20 season; in 1927 they went on to win the Sussex Senior Cup. The later photograph shows the club's ground in Oaklands Park, which was considerably upgraded in 2010.

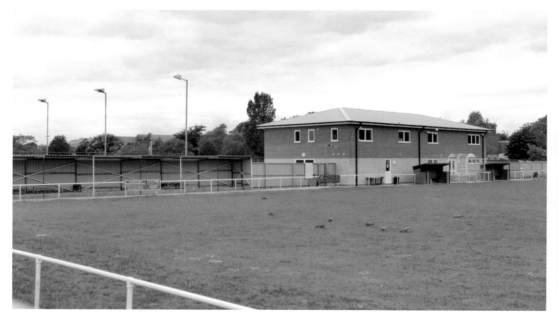

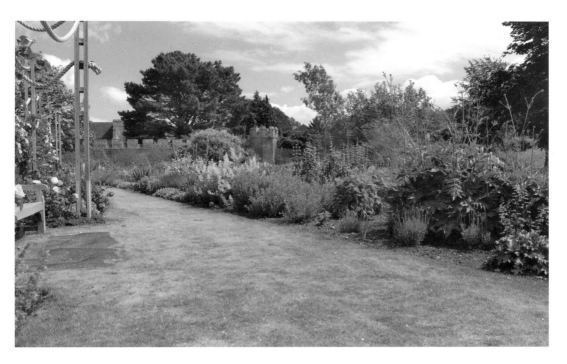

A Walk in the Park

Possibly one of Chichester's best kept secrets is that of the Bishop's Palace Gardens, located just beyond the Bishop's Palace and within the shadow of the cathedral. Its splendid gardens have long provided a quiet haven for those in the know or who have the time.

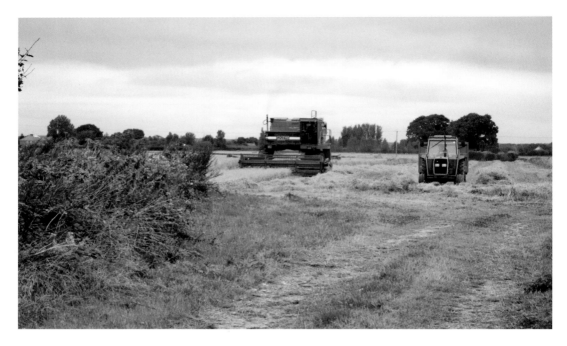

Gathering in the Harvest

Maybe not time out for the those involved in gathering in the harvest, but a spectacle occasionally enjoyed by those of the city when travelling only the shortest of distances from beyond the ancient city walls. The earlier photograph, which dates to 1943, shows local Land Girls taking in the harvest on an East Marden Farm and is compared with the use of a combine harvester on a twenty-first-century farm in Chidham.

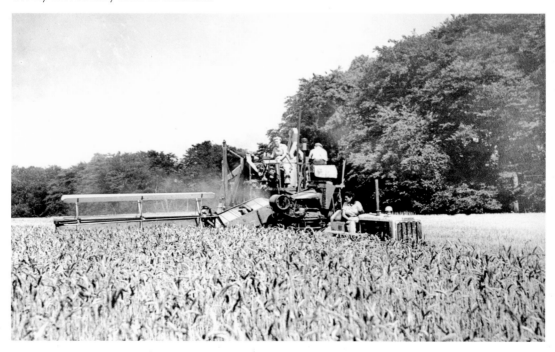

Under Starter's Orders

'With cavalcades of coaches, and crowds on foot and horseback, such as make the Derby and St Leonard's pageants' was how the *Illustrated London News* in August 1846 described this view of Chichester High Street on Cup Day. While that drawing of over 150 years ago might show morning visitors heading towards the course at Goodwood, the aerial view steps back a day and shows preparations in hand for a following race day.

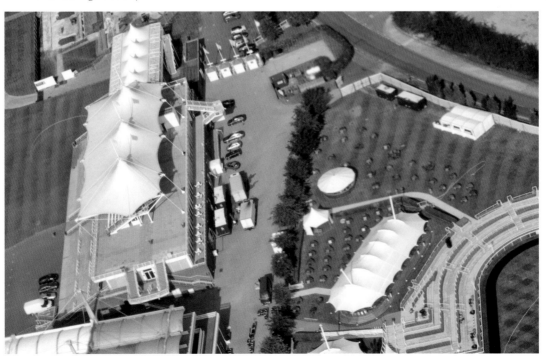

GOING TO THE RACES.—HIGH-STREET, CHICHESTER.

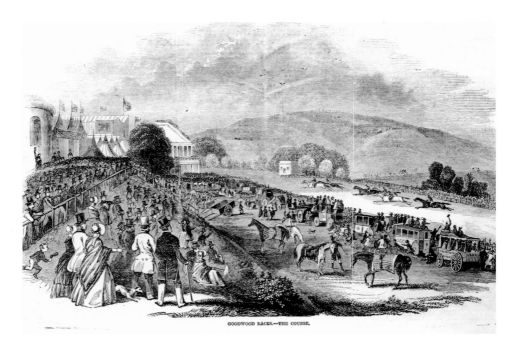

GOODWOOD RACES.—THE COURSE.

And Goodwood is the Merry Place

The print is of that same Goodwood Race course in 1846, the year in which Mr O'Brien's Grimston won the Cup run on the last Thursday in July. An exaggerated Trundle stands beyond the course, while the runners are on the last furlong. To help celebrate the occasion, the *Illustrated London News* ran with a poem that began 'And Goodwood is the Merrie Place/For Sportsmen true and steel of blood/That love the chase/And the glorious race'. Just as exciting is the photograph of the runners in that last furlong on a similar but more recent final Thursday in July.

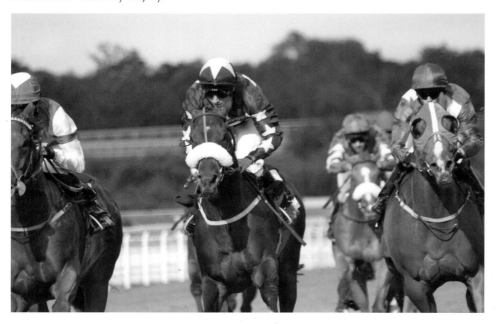

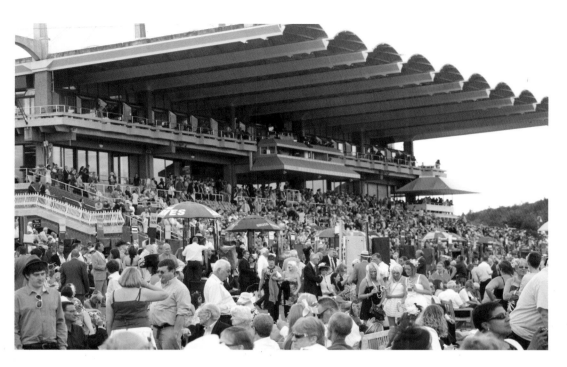

The Stands

In the modern-day photograph, the Sussex Stand at Goodwood is viewed from the Gordon Enclosure at the end of another exciting and eventful Ladies' Day. The earlier stand, which served for many years, was finally removed in 1979.

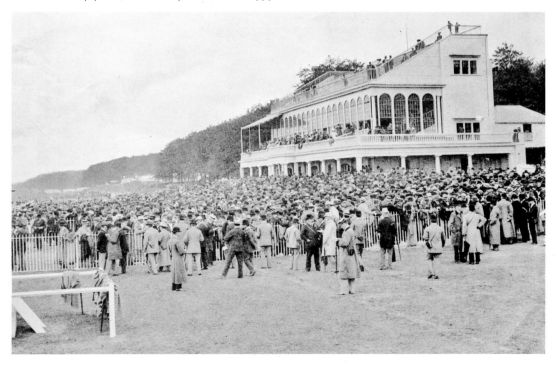

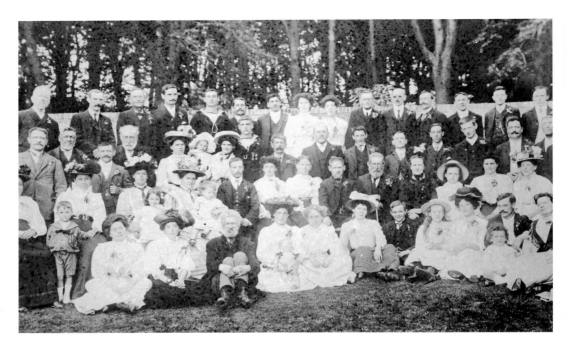

The Summer Outing

Goodwood, whether a summer outing to the race track, its undulating countryside or the stately home, has always been popular for organised parties from the nearby city. One such group, the Men's Bible Class attached to the Church of All Saints in the Pallant, whether visiting the house or the surrounding open fields, were captured on camera on 3 August 1908. In contrast is a modern-day aerial view of Goodwood House, much of it dating to the eighteenth century.

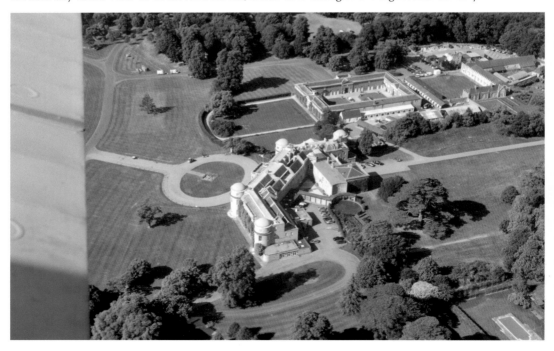

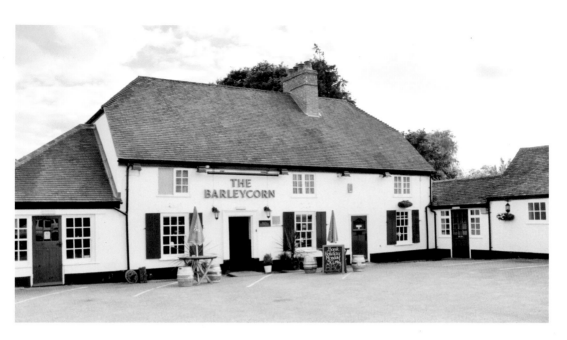

Barleycorn

Another venue popular with Cicestrians, especially when caught in those extensive traffic jams that snarled up the old A27 that was once the only road to Portsmouth, was the Barleycorn in Nutbourne. At one time, reaching back into the nineteenth century, this particular inn was much akin to a modern-day service station, not only providing food and beverages but also the services of a blacksmith to carry out instant horse shoeing for the trusty stead that was pulling the carriage along this former turnpike road.

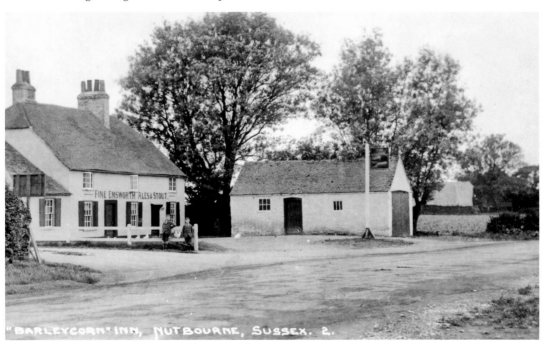

"BARLEYCORN" INN, NUTBOURNE, SUSSEX. 2.

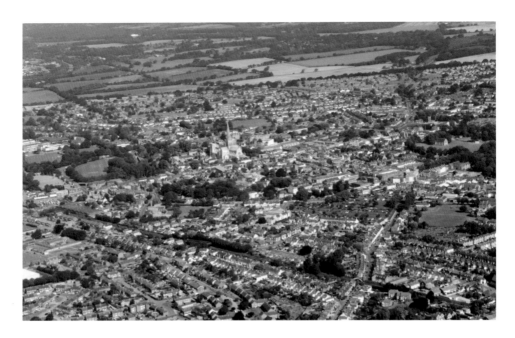

Cricket on the Green

And if the hustle and bustle of Goodwood or the excitement of roller skating hockey matches wasn't to the taste, then there was always the possibility of a much quieter afternoon watching or playing cricket in Priory Park. Here, in the number of parks and open areas, Chichester is most fortunate. In the aerial view (with the city viewed from the south-east), Priory Park and a second park are to be seen to the left (on the east side of the city), while to the right, and appearing to encircle the cathedral spire, can be seen Chichester College playing fields, Westgate Fields, the Bishop's Gardens and the Central School playing fields. In addition, and unlike many cities, Chichester is also surrounded by a great deal of undeveloped countryside.

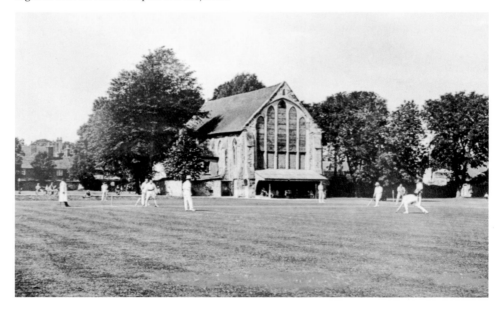

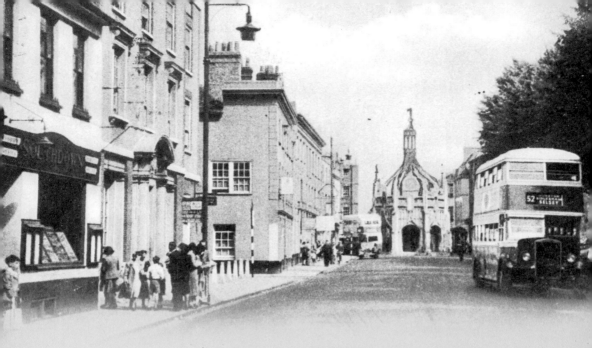

CHAPTER 7

Getting There

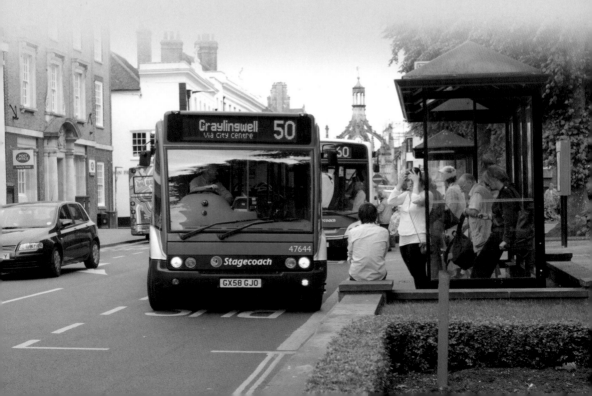

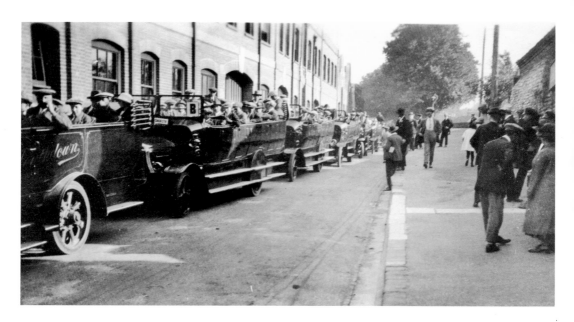

West Street

Previous page: two views of the often busy West Street bus stopping zone, the nearest joining and alighting point for the centre of the city. In the earlier photograph, a No. 52 bus in the Southdown livery is *en route* for Selsey.

This page: An alternative to West Street is the bus station itself, an area of the city that has seen better days. A long-planned interchange, an absolute necessity for the city which would much improve the local public transport experience, is seemingly on permanent hold. As for the earlier view, this gives a flavour of buses during the 1920s, when Shippams' employees were on their works outing.

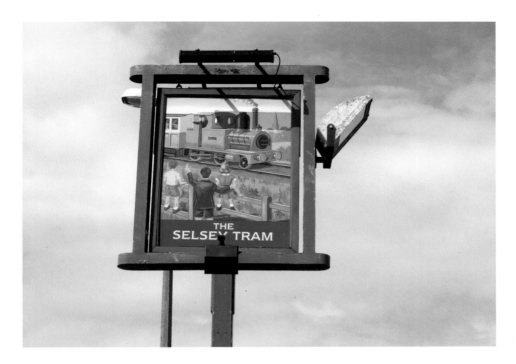

Selsey Tram

Between 1897 and 1935, an alternative means of reaching Selsey from Chichester (other than that of a regular bus service) was a ground-level light railway. Known as the Selsey Tram, or alternatively the Siddlesham Snail, it was characterised by unreliability and lateness. There is little evidence of the former line's existence, but it is remembered by 'The Selsey Tram', a pub in Donnington on the main road into Selsey. At the time of writing, while the sign board was still visible, the pub itself is under threat of demolition.

Early Motoring

Of course, not everyone relied on public transport for the purpose of getting there. In the first decade of the twentieth century, the private car began to appear in increasing numbers. In turn, this led to an increasing number of companies turning their attention to the needs of the motorist. In Chichester, the largest of these was T. S. Adcock, originally established in 1875 for the sale of bicycles. By 1920, Adcock's were situated in both North Street and Chapel Street, offering new cars for immediate use while also offering repairs and the necessary accessories to keep a newly purchased car on the road. As expansion continued, they were eventually to open an extensive showroom in Market Road, now the location of a Chinese Restaurant.

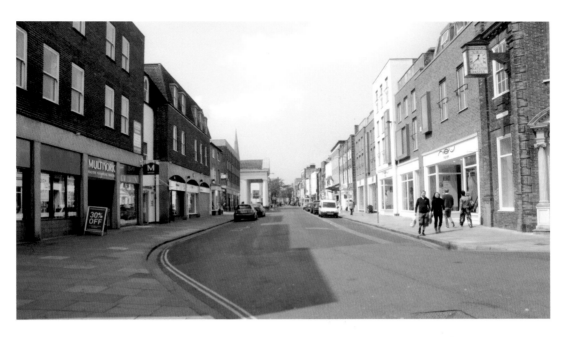

T. S. Adcock

In this *c.* 1929 view of North Street, one of T. S. Adcock's earlier shops is seen, this one specialising in the sale of cycles. However, even at that point in time they were in the process of transferring their full resources over to the motorist, with a garage at that time sited in the stretch of East Street depicted in the modern day view. Of further interest is that Reeves Garage, replete with a petrol pump, stood only a few doors to the south of the T. S. Adcock shop in North Street.

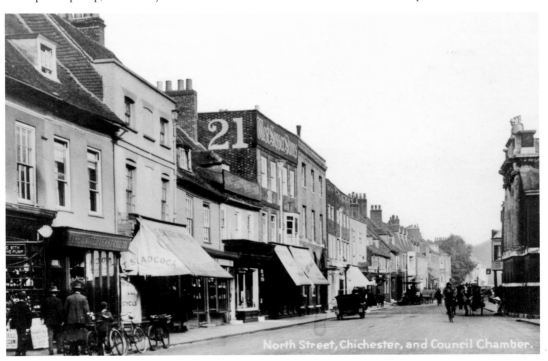

North Street, Chichester, and Council Chamber.

Stockbridge Road

A choke point for those attempting to leave Chichester, whether on a bus or using private transport, is the Stockbridge crossing, which is often kept lowered for five minutes or more.

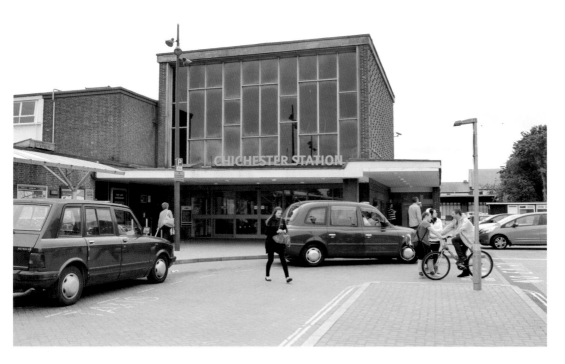

The Railway Station
It is true that Chichester is well served by rail, with frequent trains to Brighton, Portsmouth and London. The Brighton section first opened in June 1846, with the connection to Portsmouth made in the following year.

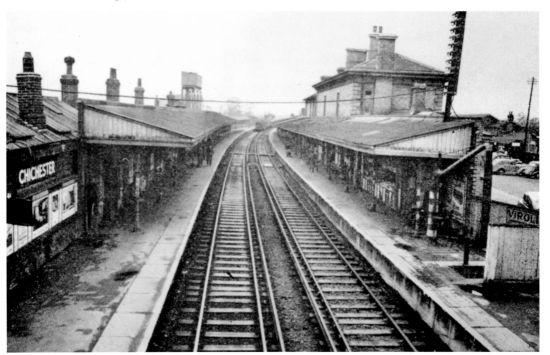

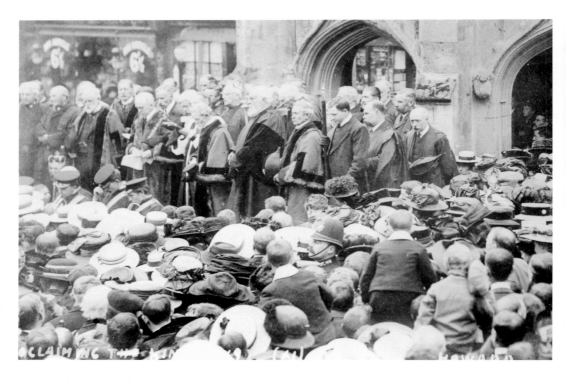

The Proclamation of George V
Following the death of King Edward VIII on 6 May 1910, George V was proclaimed at the Market Cross by officials of the city Corporation.

Acknowledgements

Most of the illustrations used in this book have been drawn from my own collection of photographs that has been built up over a number of years. In addition to these, I would like to thank Mrs Cecily Williams (page 54 top), the former Shippam's Co. Ltd (pages 18 and 19) and the late Mr Douglas Cecil (page 41 bottom) for the loan of these photographs.